# A–Z

## OF

# NORTHAMPTON

PLACES - PEOPLE - HISTORY

Anthony Meredith

AMBERLEY

*Northampton grows upon one. When I was first told that it was called*
*'the proud beauty of the Midlands', the name seemed to me an absurd exaggeration,*
*but now I think it is not too grand a designation.*
—Marianne Farningham, *A Working Woman's Life*, 1907

First published 2017

Amberley Publishing
The Hill, Stroud, Gloucestershire, GL5 4EP
www.amberley-books.com

Copyright © Anthony Meredith, 2017

The right of Anthony Meredith to be identified
as the Author of this work has been asserted in
accordance with the Copyrights, Designs and
Patents Act 1988.

ISBN  978 1 4456 6572 6 (print)
ISBN  978 1 4456 6573 3 (ebook)

British Library Cataloguing in Publication Data.
A catalogue record for this book is available
from the British Library.

Origination by Amberley Publishing.
Printed in Great Britain.

# Contents

# Introduction

Northampton is on the move. The town is expanding significantly, embracing the advantages of a cosmopolitan identity and regenerating its heartland with a sensitivity towards heritage issues that was sadly missing in the previous century. Its university advances in prodigious leaps and bounds. Its new marina, revitalised railway station and state-of-the-art skate park exemplify the spirit of adventure. The current slogan of 'Northampton Alive' seems very apt.

It is a good moment, then, to take stock. As we do so, one representative family will be threading its way through the kaleidoscopic narrative. Five generations of Arnolds were involved in the town's great shoemaking industry, two of the highly productive Arnold factories being part of a golden age when it was the proud boast that 'the Northampton shoe is known wherever men and women walk in leather'. The most celebrated family member is the Oscar-winning Sir Malcolm Arnold (1921–2006), one of Britain's great composers and a helpful reminder that there is so much more to Northampton than its prodigious shoemaking exploits and the resultant legacy of a unique townscape. Its cultural heritage is broad and its medieval roots grew deep. We shall be exploring a fascinating town, rich in buildings, personalities and history.

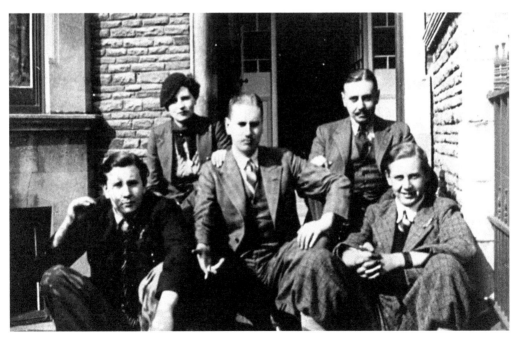

A late 1930s snapshot of Malcolm Arnold (left) with his sister Ruth and brothers Cliff, Aubrey and Phil.

# A

# 1. Admirable Alex Anderson

Several outstanding Northampton architects of Victorian times deserve much wider recognition than they currently receive. The youngest of these, Alexander Ellis Anderson (1866–1935), was a Scot who arrived in 1893, briefly worked in partnership at No. 36 Victoria Road and then ran his own flourishing practice at various addresses (No. 64 Abington Street, No. 17 Market Square, and, in premises designed by himself, No. 28 Hazelwood Road). He lived for a time at 'Hill Crest' in Christchurch Road, part of an attractive terrace he himself created in Arts and Crafts style, before moving to No. 72 Derngate.

His buildings reflect his cheerful personality. A good example is his flamboyant warehouse in Fish Street for the Glasgow leather and hide importers, Malcolm Inglis. He playfully borrowed classical devices like the huge rusticated pilasters that rise up either side of the building, flamboyantly included the sculptured heads of two bulls as proud advertisements of the quality of Inglis leather, and cheekily entrusted his lavish tribute to Glasgow (over the main entrance) to the care of two voluptuous ladies.

Entirely different is a memorial hall in Castilian Street, commissioned by Malcolm Inglis' director, David Paton Taylor, whose son Ralph was killed at the Somme in 1916. Anderson's startling eye-catcher of a design in Scottish Baronial style brings a touch of Harry Potter to Northampton. The hall was specifically to be used 'for the good' of those for whom the First World War dead had given their lives. Employed first as a military hospital and then, for many years, as a YWCA hostel, it is currently the home of the lively Borjia club. Anderson's imaginative interior, with its stone spiral staircases and minstrels' galleries, is so bold it even holds its own with Borjia's interestingly ornamental fittings and décor. Outside, Ralph Paton Taylor's initials can still be seen on high between the two central turrets, as can Alex Anderson's signature, inscribed in stone just to the right of the main entrance.

Anderson was very much a trendsetter. A strong ambassador for the Edwardian craze of golf, he was also a pioneer motorist. The 'motor house' he designed for himself was probably the first garage in the town.

Anderson's warehouse, Fish Street.

Anderson's memorial hall, Castilian Street.

# 2. Adventurous Arnolds

William (Billy) Arnold (1860–1945) conquered considerable handicaps to create a great family business. One of fourteen children growing up in a cottage in rural Everdon, where his impoverished father stitched shoes, he had virtually no schooling and would never be fully literate. He had, moreover, the misfortune of being born with one eye. At six, Billy was working as a scarecrow; at seven, as a 'sprigging boy' riveting boots. But he never lacked ambition. In his early teens he moved to Northampton, where an uncle found him employment with shoemakers in Cyril Street and St Edmund's Road, and by his twenties, as an expert riveter, he was getting work from the Campbell Square factory of the great shoe baron Moses Philip Manfield. He began to dream big.

First, he rented No. 29 Hunter Street 'where there was a nice little riveting shop at the back, large enough for five men to work in'. Then, in 1891, and just turned thirty, he and his uncle Anthony borrowed money to form 'Arnold & Co.' with another relative

acting as bookkeeper. They began modestly in 'one room up some steps' in Duke Street, with house-factories quickly following in Military Road and Turner Street. But having acquired their first complete factory in Louise Road, they badly over-reached themselves, the subsequent acrimonious crash involving debts that would take twenty years to clear. Unabashed, Billy and Uncle Anthony found new backers and launched 'A. & W. Arnold', still in Louise Road. It did so well that Billy and his growing family were soon living at No. 49 Colwyn Road with a garden backing onto the Racecourse. In the late 1890s large factories and modern machinery were the way forward, so he took a further gamble. Borrowing so heavily that Uncle Anthony opted out, Billy took 'A. & W. Arnold' to extensive premises, recently vacated by Allinson's, with a frontage in St Giles' Terrace. It made big money and expanded down The Riding, enabling Billy to move his family to the other side of the Racecourse, No. 26 Kingsley Road, and invest in a small country house in Everdon.

In 1909 William Arnold Snr (as Billy now preferred to be known) gambled again, buying his two eldest sons, Will (1886–1978) and Matt, their own factory, 'Arnold Brothers'. By 1915 the two separate firms together employed 800 workers, producing over half a million boots and shoes a year. Both were now among Northampton's élite, its top twenty manufacturers.

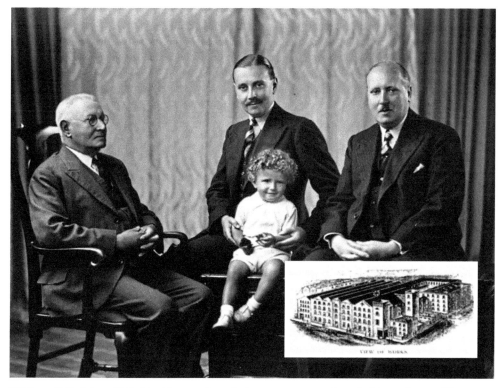

William (Billy) Arnold (left) with grandson Aubrey, great-grandson Robin and son Will. *Inset*: The A. & W. Arnold factory, St Giles' Terrace.

They rode out the hard 1930s, and when William Snr eventually retired, his sons and nephews took over. The sale of boots prospered in the Second World War to both factories' advantage. After Billy's death in 1945, however, the family lost control of 'A. & W. Arnold', and fierce foreign competition in the 1950s led to its closure and demolition. (Today the site of its main entrance is marked by the modern office block, Aquila House.) After Will retired, 'Arnold Brothers' struggled on under his hard-working son Aubrey, a Cambridge graduate and wartime gunnery officer. But in 1961, devastated at being ousted from the board, Aubrey committed suicide. The firm did not long survive the tragedy. Once popular brand names like Billy's 'Majestic' and 'Welfit' and Will's 'Master' and 'Cathedral' were a thing of the past. The proud cry that 'Cathedral shoes wear out the pavement' was to be heard no more.

# 3. Atmospheric Abington Park

With the sound of brass coming from the bandstand on a summer's Sunday afternoon, delightful Abington Park exudes a sense of timelessness. It was opened to celebrate Queen Victoria's Diamond Jubilee but has buildings from many centuries further back, when Abington was a village. There's the still-flourishing parish church of St Peter and St Paul, for example, whose many old features include a Grinling Gibbons pulpit. Nearby is a sixteenth-century manor house, now a museum, once the home of Shakespeare's granddaughter Lady Elizabeth Barnard, who was later buried in the church.

The eighteenth-century actor David Garrick was a regular guest at the mansion when the flighty and spendthrift Anne Thursby was its mistress. On one visit Garrick presented her with a sapling of a mulberry tree 'as a growing testimony of their friendship'. Planted close to the manor house, it flourished over the centuries and is still to be seen today near the Park Avenue entrance. So too is a bust of Garrick in the museum. A bust and a tree would at least have been some consolation to poor Anne Thursby during her beloved Garrick's long absences.

The museum is, and always has been, very special. The Arnolds were typically enthusiastic visitors. Malcolm's sister Ruth (1909–66), who particularly loved its quaint atmosphere, wrote:

> Step carefully over the chill ghosts that linger in the hall. Speak softly – the place is alive with memories of a distant past. I remember a large oak chest which frightened us (my brothers and me), so sure we were that, on lifting the lid, a mass of rotten bones would greet our terrified eyes. There were stuffed animals, relics of another age. Birds, poised, ready to fly away. I remember tea and ices in the café in the courtyard, where I could swear I heard the horses' hooves on the cobbled stones and sensed the swish of garments – vast capes and satin petticoats. Reality there was as artificial as a stage-set and as out of place as the empty ice-cream cartons.

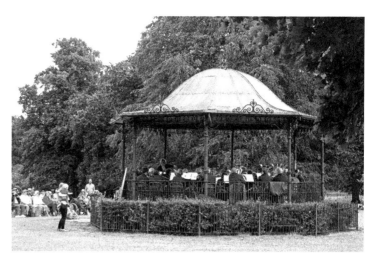

The Rushden Town
Band, Abington Park.

The Abington Park Museum entrance.

# 4. Awesome All Saints'

Music is at the heart of All Saints'. A splendid choir sings beautiful music. Attend a service and you may well be greeted with Mozart, Bach or Schubert. There's the benefit, too, of a strong musical tradition. Many famous modern composers, from Richard Rodney Bennett to James MacMillan, have been commissioned over the years. What with the music, the incense and the glorious seventeenth-century setting, a service at All Saints' is, in all senses of the word, awesome.

Yet it is welcoming too. So many churches these days seem distressingly like Fort Knox. Not so All Saints', which opens every day. It helps, of course, that it has created, most sympathetically, a bistro where customers can sit at leisure beneath the pillared

portico and watch the town go by, or muse upon the original medieval church, burnt down in the Great Fire of 1675. The church was in the centre of the small medieval town. Roads radiated from it towards the town gates.

Painstakingly rebuilt after the fire, largely in rich, golden Northamptonshire ironstone, it was opened in 1680. There's an inscription running along the portico's frieze, explaining the presence of an important benefactor: 'This statue was erected in memory of King Charles II who gave a thousand tuns of timber towards the rebuilding of this church and to the town seven years of chimney money collected in it.'

With its tower, portico, cupola and lantern dome behind, All Saints' presents a charmingly coordinated mix of the Gothic and Classical: 'In theory,' commented Dr Ernest Reynolds, 'this quaint jumble of styles should prove bewildering, but in fact the work is of tremendous character, absolutely individual and unforgettable.' Indeed it is.

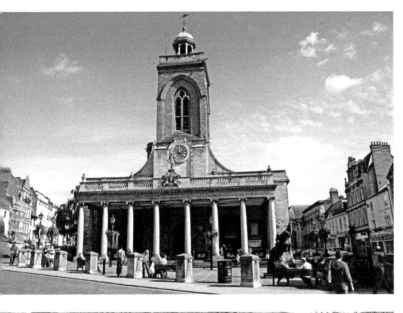

All Saints' Church.

All Saints' bistro.

# B

## 5. Bad Old Bridge Street

It is easy to romanticise the past and bemoan its destruction – to lament, for example, all the lost coaching inns, like the Angel on Bridge Street and the Saddlers' Arms opposite, where old Dan Muscutt's sausages and mash were said to be second to none. Bridge Street, indeed, is instructive. It sloped importantly down from All Saints' and led, across a former medieval moat, to the road to London, and yet it was anything but romantic in mid-Victorian times according to George de Wilde, reminiscing in 1872:

A Bridge Street student of 1753.

Bridge Street is everything that a great thoroughfare ought not to have, and nothing that it should have. It is narrow; has hollows and steeps; is dirty; its paving is always out of order; it is choked with unsavoury smells; is smoky; squalid; always crowded with brewers' drays and trollies and carts full of the deposits of the pig-sty. Late on a November night when the fog lies low and undisturbed you walk through distinct strata of smells – grains, pig-sties, oil cake, tallow-melting...

Ironically, George De Wilde even disliked one of the buildings most treasured in Bridge Street today, the former Corporation Charity School of 1811 with the statues of two former students in niches on its distinctive façade: 'As ugly a bit of nineteenth-century architecture as the nineteenth century has produced.'

# 6. Bareback on Billing Road

In Billing Road Cemetery there is a striking sculpture in Italian marble of a despondent horse. It celebrates Sir Robert Fossett, arguably one of the greatest bareback riders in circus history. He died in December 1922 in Northampton, while the circus that Sir Robert ran was, as usual, wintering at nearby Kingsthorpe. Sir Robert hadn't actually been knighted for his bareback prowess. His circus-owning father, similarly titled, had simply copied an idea from his great rival George Sanger, who had elevated himself to 'Lord George'.

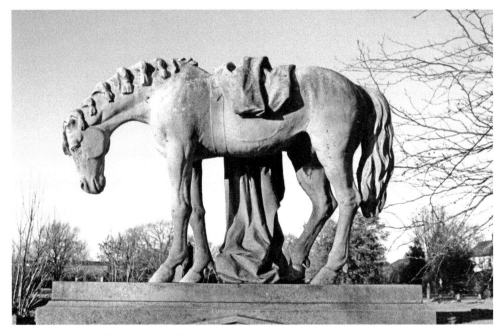

The monument gifted by Bostock's Circus.

Billing Road in the days when Fossett's Circus flourished.

The statue has unfortunately suffered the loss of a marble book on which the horse was looking down reflectively. On its open pages was an inscription declaring that the memorial to Sir Robert had been erected 'by all the artists at E.H. Bostock's circus'. The resourceful Edwin Bostock, born in nearby Stony Stratford, was a contemporary of Fossett's, his autobiography charting a life devoted to the organizing of ever grander tours and entertainments. Bostock had made a fortune in the process, and though, no doubt, all the members of his circus made a small contribution, Bostock, a great philanthropist, probably bore the brunt of the memorial's expense. Thanks to this act of generosity, the talented Sir Robert, the daredevil star of Fossett's Circus who thrilled and amazed Victorian Northampton, can still live on in our imagination.

# 7. Becket's Park Ghosts

Becket's Park, created in the 1780s beside the River Nene, celebrates the famous Archbishop of Canterbury who, having fallen foul of Henry II at Northampton Castle back in 1164, was forced to flee for his life. En route for France, he stopped, so legend has it, outside the town's 'Dierne' Gate to refresh himself with water from a spring. It can be found today at the top of the park, enclosed by an attractive little pavilion provided by the history-conscious Victorians, its potential as a visitors' attraction somewhat damaged by the streams of Bedford-bound traffic passing within mere inches. But the park itself, sloping down towards the 'silver' Nene and the fine new marina, provides a splendid green space in the heart of the town.

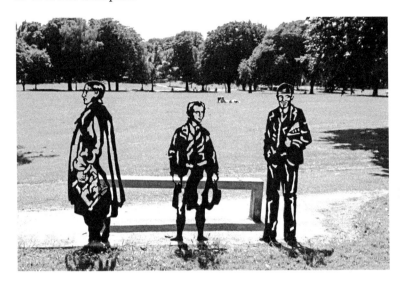

Left to right:
Charles Rennie
Mackintosh, John
Clare and Wenman
Bassett-Lowke,
Becket's Park.

There is a highly imaginative recent acquisition at the top of the park, not far from Becket's Well. Erected in celebration of the town's contribution to the National Cycle Network (a route from Becket's Park to Upton), it consists of three remarkable 'siloquettes', two-dimensional life-size portraits in laser-cut steel of inspirational figures from the past. A nearby bench identifies the three as toymaker Wenman Bassett-Lowke, poet John Clare and architect and designer Charles Rennie Mackintosh. Standing out in all weathers since 2007, the steel tributes have now, as intended, turned a rusty brown. But with sunlight behind them, streaming through skilfully made gaps, they spring to ghostlike life and take magnificent control of the landscape.

# 8. Beguiling Bassett-Lowke

Wenman Bassett-Lowke (1877–1953), celebrated so unusually in Becket's Park, began life simply as Joseph Lowke. But as the son of a successful Northampton engineer and boilermaker, he had big ambitions, and so, at the age of twenty-two, he not only began his own model steam-engine business by mail order from the family premises at No. 20 Kingswell Street, but also adopted a somewhat more sonorous new name. He was a hyperactive and quick-witted young man, with a consuming passion for all that was good and new. Making a name for himself was exactly what he was all about.

A visit to the Exposition Universelle in Paris in 1900 proved very helpful, alerting him to German pre-eminence in toymaking generally and the model railways of Nuremberg manufacturer Stefan Bing in particular. Working from St Andrew's Street and Kingswell Street (where Alex Anderson designed him new workshops), Bassett-Lowke quickly became the leading British name in model railways, adroitly using German suppliers to maximum advantage. His eye for arresting modern

design embellished his extensive catalogues, in which he would dispense confident advice to his clients: 'As a present to youth, nothing can be more suitable than a model steam engine in one or other of its many forms.' Just a little vigilance would ensure no messiness: 'It will certainly not be the fault of the model engine if half the water is poured on the carpet instead of in the boiler, or if the cork is left out of the methylated spirit bottle, and the latter knocked over by the young engineer's elbow, as he turns to invite the admiration of the family to the excellent working model.' By 1904/5 he was offering twenty-five different steam locos, another twelve with clockwork engines, and his very first electric loco (the LNWR's celebrated *Charles Dickens*).

He skilfully played down his important German associations in the First World War but in 1920 there were further anxieties when Meccano launched the Hornby 0-gauge railway, seriously threatening his business, which involved not only Gauge 0 but the larger 1, 2 and 3 too. He also started retailing German-built railways half the traditional size, initially with only limited success, but by clinching a deal in 1935 with Stefan Bing's new Trix Co., the Bassett-Lowke Twin Train Table Railway was able to make big inroads into the Hornby 0-gauge market. Meccano responded in 1938 with their own version of the 00-gauge, the Hornby Dublo, costing just a quarter of the Bassett-Lowke. Although he could never again challenge Hornby, Bassett-Lowke maintained a small but faithful section of the market.

His firm eventually went out of business in 1965, twelve years after his death. Its arresting name, however, has continued to be marketed, most notably by Corgi and Hornby. Vintage Bassett-Lowke items on eBay reflect their prized status. A boxed *Duchess of Montrose* LMS train (no carriages) sold for £2,000 and a *Flying Scotsman* for £600. An LMS restaurant car at £675 makes a LNER buffet car at £374 look cheap and a £280 Post Office coach (with line-side delivery apparatus) a positive snip. Meanwhile a lowly engine shed could fetch £185, a bookstall £119 and a single signal £35. There are interesting Bassett-Lowke exhibits at both No. 78 Derngate and the museum in Guildhall Road. A Bassett-Lowke Society also flourishes.

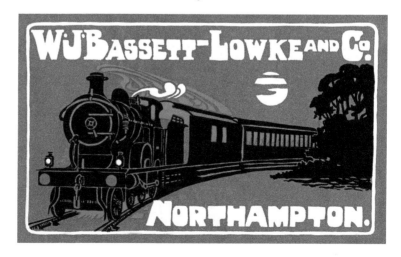

The 1904/5
catalogue cover.

# 9. Big-time Barratt's

'He who has goods to sell should holler, not whisper down a well'. Such was the advice of the founder of one of the town's greatest boot-and-shoe empires, William Barratt (1877–1939). And holler he did, right from the start. It was quite late in the boot-and-shoe golden age when, in 1903, he and his brother David started W. Barratt & Co. at the Sterling Shoe Works in College Street with the compelling slogan 'Walk the Barratt Way!' Rivals were soon shaken by the lavish brochures and high-level advertising of Barratt's pioneering mail-order business. Even an unfortunate lapse into receivership in 1906 didn't stop them. In 1913, with all debts paid off, the town's most flamboyant architect Alex Anderson was employed to design new eye-catching, red-brick, neo-baroque premises with 'Footshape Boot Works' emblazoned on high. Footshape referred to Barratt's unique offer of low-cost boots made to order. 'If you do not know the size you take either in length or width,' ran one early advert, 'send an old boot or place your stockinged feet on a sheet of paper and draw an outline by passing a pencil round.'

Handsome, dark-haired and dapper, the young William Barratt gazed confidently from his brochures with a light but stylish walrus moustache, waxed at the ends. He was a shoe baron with a difference. A committed member of the Social Democratic Federation, the first Marxist party in Britain and the forerunner of today's socialists, he alarmed his fellow bosses with his advanced views on working conditions and eventually, when he was president of the Shoe Manufacturers' Association, he succeeded in introducing a shorter working week. When having a new home built for himself (Stonehenge, No. 1 Park Avenue), he also provided new terraced accommodation for his workers close to the factory. A leading Congregationalist, he was generous with his wealth, most notably in funding the William Barratt Maternity Hospital, opened by Princess Alice in 1936.

Like the Arnolds, Barratt's struggled in the 1950s against foreign competition. In 1964 the family-run business was taken over by Stylo, the factory finally closing in 1997 and being pulled down, except for its important front section, Alex Anderson's wonderful *jeu d'esprit*. The brand name lives on.

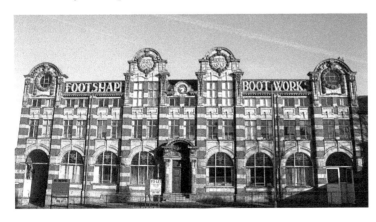

Barratt's in Barrack Road, designed by Alex Anderson.

# C

## 10. Castle Calamitous

Once upon a time, on a hill by a river, there was a fine castle where kings held parliaments, knights jousted doughtily and Thomas à Becket was bettered by Henry II. 'The castel standeth hard by the West-gate and hath a large kepe,' wrote Henry VIII's librarian in 1536. 'The area of the resideu is very large.' It was a very fine castle indeed. But then came Civil War, ill-advised support of Roundheads and a Cavalier moment of revenge, when Charles II espied, on a hill by a river, a very fine castle whose partial destruction delighted him. But there were still its comely remains, and what with its large keep and residue, its hill and its river, it was all distinctly picturesque, until, in 1879, an evil fairy, with the initials LNWR, waved her wand and, lo and behold – or, rather, <u>not</u> behold, for suddenly there was no castle, no hill and no river. Just London & North West Railway's new station and engine sheds. Perhaps the finest, and certainly the flattest, in the land.

Recently, of course, a good fairy waved another wand and that station became even finer. And the story may yet not end unhappily ever after. For the local community's 'Heritage Gateway' project has suggested that the coming redevelopment of an

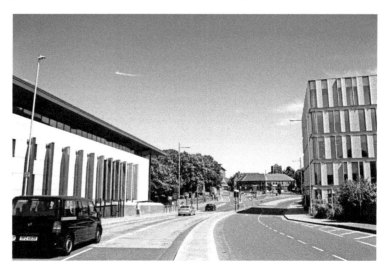

The railway station, the tower of St Peter's Church and the University Innovation Centre.

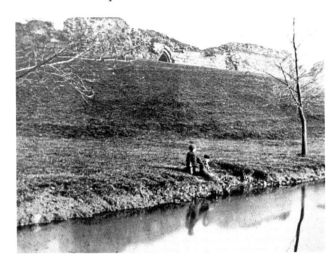

The castle ruins and river before the coming of the railway.

adjacent site could mean an attractive open space for residents and visitors within the castle's 'large resideu', opening up a vista between historic St Peter's and Castle Hill. There, an imaginative exposition of the castle's history could be enhanced by excavation of considerable remains. 'For there is a great deal of the castle left under the surface,' say its passionate supporters. 'It can be both explored and restored if we have the will to do it'. Castle Calamitous can never again become Castle Colossal. But it could yet become Castle Conserved.

# 11. Church of Church's

Alfred Church (1850–1928) was another of the town's great shoe barons, guiding a family company that had origins in the seventeenth century. Alfred's unstoppable successes began in 1873 when, with his father and two younger brothers, William and Thomas, he took over premises in Maple Street. Next year they moved to Duke Street where, between 1877 and 1893, they built three adjacent factories, the heart of Alfred's empire in the shoemaking golden age. Though the firm eventually moved out of Duke Street in the 1950s, these three buildings, along with an adjacent curriers (Hegg's), survived into the twenty-first century. In 2001 the old Hegg's building was turned into a modernist apartment block, the Lightbox, and, more recently, the two older Church buildings were demolished, leaving only the tall block of 1893.

Alfred Church and his family lived for many years in Melbourne Crescent, in the house now occupied by the Cheyne Walk Club, where Cheyne Walk meets Spencer Parade. A fine example of Victorian Gothic architecture, it was designed in the 1860s by another of the town's distinguished architects, Edmund Law. Alfred was responsible for the house's extension (currently the club's lounge and bar). Its remarkably ornate fireplace and fine wooden panelling survive; so too Alfred's initials, to be found within the design of the stained-glass windows. During Alfred's time, the house faced onto

open fields that ran all the way to Houghton and beyond. This would have been a great attraction to him, for he was a passionate rider who hunted with the famous Pytchley Hunt most of his life. He kept his horses in the stables in Spring Gardens, where he had also purchased property.

A strong supporter of the Congregational Church, he took his position within the business community seriously, acting as honorary treasurer of Northampton Boot Trades Association for over twenty years. He played a key role in the Chamber of Commerce, and he and his successful cousin Alfred Tebbutt founded the Junior Chamber. With Church's close support, Tebbutt also pioneered the Shoe and Allied Trades Research Association.

Though taken over by Prada in 1999, Church's is still synonymous with high-quality shoes. The firm has been in its current extensive premises in Spencer Street since 1957.

The former Church factory in Duke Street.

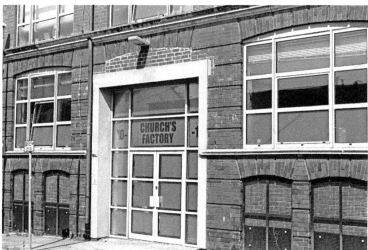

Modern apartments in the old Duke Street factory.

# 12. Clare Celebration

The fame of John Clare (1793–1864) continues to grow: 'No-one has ever written more powerfully of nature, a rural childhood and of the alienated and unstable self,' wrote a recent biographer. It was Clare's instabilities, of course, that led him to spend his last twenty-three years in what is now St Andrew's Hospital, from where he would often wander to All Saints' to sit quietly under its portico and write poetry.

The town has long championed his cause. Clare Street, an integral part of the Boot and Shoe Quarter, was the Victorian tribute. The poet of the countryside would have hated the overcrowded workshops of the large Tebbutt factory on the corner of Grove Road, though its imaginatively conceived conversion to apartments might have appeased him. He might have smiled, too, to learn that Strickland's on Clare Street created the special shoes of Coco the Clown, star of Bertram Mills' Circus. There's a splendid Clare archive at the public library, with his own books, bookcase and manuscripts; a life-size sculpture in the courtyard of the Guildhall extension; a bust in the café of All Saints', with his poem 'I am' on the wall behind; and, of course, the ghostly 'siloquette' in Becket's Park. Malcolm Arnold knew Clare's poetry well. His major tribute, written in the 1950s, was a 'John Clare Cantata' for chorus and piano duet. It includes a beautiful setting of 'Spring':

A bronze John Clare in the Guildhall courtyard.

Clare Street: an intimate theatre and former factory.

Come hither, gentle May, and with thee bring
Flowers of all colours, and the wild briar rose;
Come in wind-floating drapery, and bring
Fragrance and bloom, that Nature's love bestows–
Meadow pinks and columbines,
Kecksies white and eglantines,
And music of the bee that seeks the rose.

# 13. Classy Cliftonville

In 1840 the Corporation sold off land to the immediate east of the town on the proviso that 'only high-class buildings should be erected'. Detached villas, each in around an acre of land, duly began to appear in Cliftonville, a turning off the Billing Road with panoramic views over the open countryside leading down to the Nene Valley. When the illustrious Moses Philip Manfield moved into 'Redlands', Cliftonville's reputation was made. Other prestigious shoemaking families were also represented, Church and Hawkins prominent among them. So too the powerful Phipps brewery family. In those days the street carried on beyond the intersection of Cliftonville Road into a short cul-de-sac (now part of The Avenue), on the south side of which were five more villas. The middle one, not without good reason, was called Fairview. And there, in 1921, Malcolm Arnold was born.

His father, Will, had been running the Arnold Brothers factory with great aplomb for twelve years. The increased demand for boots during the First World War brought great prosperity, and in its aftermath he had made a major statement to the town by moving out of his semi-detached home in Stimpson Avenue and into Cliftonville. The acquisition of ivy-clad 'Fairview' sealed the elevation of Malcolm's father into the top of the Northampton business hierarchy in which his grandfather already moved.

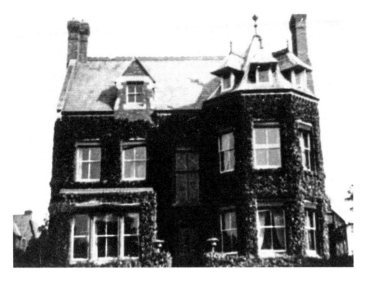

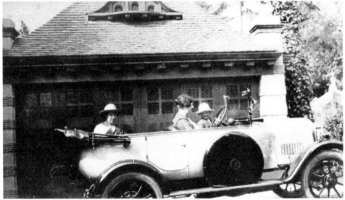

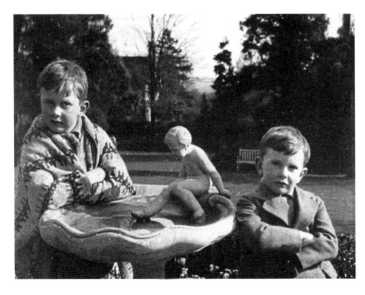

Snapshots of Fairview, the Arnolds' home in Cliftonville, with Annie (at the wheel of the car) and (below) her sons Philip and Malcolm.

With its trellised rose garden, secluded tennis court and a garage with rooms above for his chauffeur, it really was a highly desirable residence.

Today, despite the survival of a number of attractively grand houses from the days of the Arnolds, the exclusive ambience has been diminished by the combination of new development and the encroaching facilities of the hospital on the southern side. Most disappointingly, the birthplace of the town's great composer has gone, a victim of the modern need for higher-density living.

# 14. Crockett & Jones

The Grade II-listed factory complex of Crockett & Jones is still very much a working concern. Funded by a trust that supported 'young men of good character', brothers-in-law James Crockett and Philip Jones had begun in Carey Street in 1879 with a workforce of twenty. In 1897 they took over a recently built factory in Magee Street with a beautifully symmetrical design, its central façade having more the appearance of a Methodist chapel than industrial premises. Steady expansion led, in 1910, to a four-storey block down Turner Street, the first steel-framed building in the town, in its day arrestingly modern with extra daylight from large windows. By the 1920s there were over 1,000 employees, and in 1935 a second new wing was added, down Perry Street, including a new main entrance of attractive art deco design.

The Crockett & Jones factory, Magee and Turner Streets.

A crucial element in Crockett & Jones' longevity was their willingness to invest in retail shop ownership, something that the Arnolds felt unable to do, along with many other companies that came to grief in the post-war years. Aiming their high-quality products at the top end of the market, Crockett & Jones today have two shops in London's Jermyn Street and others in Knightsbridge, the Royal Exchange, Canary Wharf, the Burlington Arcade, Birmingham's Burlington Arcade, New York, Paris and Brussels. When Philippa Jones joined the board in 2006, the family's involvement had stretched to the fifth generation.

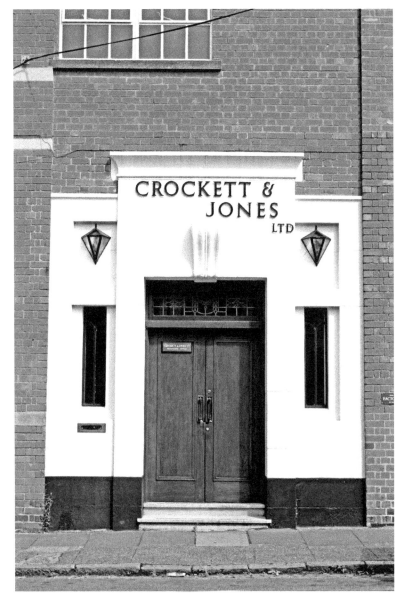

The Perry Street entrance.

# D

## 15. Dissenting Dr Doddridge

When a group of nonconformists decided to build a meeting house on Castle Hill in 1695, they were lucky to have some useful material to hand – stones from the castle disabled by Charles II. It was a small, modest building, but destined to become very well known thanks to the arrival of a star exponent of religious dissent and one of the great British preachers of the eighteenth century, Philip Doddridge (1702–51). Larger than in its heyday thanks to Victorian additions, and known today as the Doddridge United Reformed Church, the historic, listed Meeting House enjoys a secure place in the history of English nonconformism.

The uncompromising Doddridge Chapel. The south colonnade was added in 1895.

Ironically, Dr Doddridge was initially diffident about the invitation to come to Northampton: 'I cannot believe that I was ever born to shine in so polite and learned a county as Northamptonshire,' he wrote. But he quickly became an institution. Well over 200 people would cram into the little chapel every time he spoke. Intent on engaging with all classes, ages and intellects, he had no truck with the permissive times in which he lived. He was a byword for generous giving to the poor; stood up for the rights of the underprivileged; founded a school in Sheep Street, which became internationally famous; and co-raised the funds to found the town's first infirmary. He was a great hymn writer, and some of the more famous are still to be heard. As an indefatigable writer, too, he was able to reach the whole country and beyond. His biggest success, *The Rise and Progress of Religion of the Soul*, went all over the world. Dedicated to his friend, the famous hymn writer Isaac Watts, it was said to have sparked the conversion of the great social reformer William Wilberforce. John Wesley championed Doddridge's equally successful *Family Expositor*, which paraphrased and explained the New Testament. So, too, did the great Victorian preacher Charles Spurgeon.

Philip Doddridge lived in a house in Mare Fair with his wife and nine children. He was forty-nine when tuberculosis ended his fearless crusade.

# 16. Distinguished Delapre

The future of Delapre Abbey was in doubt, on and off, since the Second World War led to its requisitioning by the War Office and the long tenure of the Bouverie family came to an end. In 1948 the Borough Council bought the abbey to prevent demolition, and two years later it became a stop-gap Records Office. A £6.3-million restoration has now brought it an assured future as a heritage site, offering 'exciting displays, hands-on activities and atmospheric exhibitions that will bring Delapre's history alive'. There will be plenty of material available, for the abbey was for 400 years a nunnery and then, for another 400, the home of two distinguished families. The abbey in its current form dates to the 1760s, when the Bouveries had just taken over from the Tates.

The nunnery years should offer particularly rich historical material. Founded at the height of the town's medieval grandeur, in 1145, and known as the nunnery of St Mary de la Pré, ('St Mary of the meadow'), it enjoyed an influential position just outside the town walls, by the road that led to London. In 1460 during the War of the Roses, the Battle of Northampton was fought in its grounds. While the old Duke of Buckingham set about fortifying the Lancastrians' position in the boggy meadowlands beside the nunnery, the ineffective king of the day, Henry VI, was left in the care of the monks of Greyfriars. At the last minute, as the Yorkists, with Salisbury, Warwick and the future Edward IV at their head, marched up to Northampton from the south, the king was positioned by Buckingham in a safe position at the back of the Lancastrians' camp.

The Yorkists eventually won the battle, killing Buckingham, but only after the sudden defection to their side of Lord Grey and his forces. King Henry made no attempt to flee. 'After he had recovered from the shock that the battle must have caused to his gentle, kindly soul,' wrote a historian, 'he was brought into Northampton "wythe processyone" by the triumphant Yorkists. "He rested hym III dayes" and was then taken to London.' The abbey's peaceful walled garden, notable today for its herbs and a controversial statue made in the 1950s (Frank Dobson's *Woman With Fish*), is thought to contain the remains of the fallen.

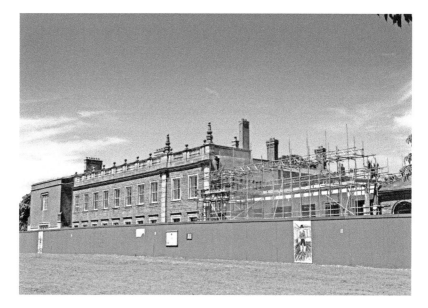

Delapre Abbey under restoration.

Sir Frank Dobson's 1950s sculpture in the Delapre herb garden.

# 17. Dunster Street Dreaming

Dunster Street, nestling discreetly behind the busy St Michael's Road, played an integral but unobtrusive part in the boot-and-shoe industry's golden years, offering backup facilities rather than the finished product. Today, its northern side has a long line of sleepy terraced houses, their original red brick of the 1880s offset now and then by a variety of whites and creams. They face similar homes, dotted between clusters of industrial buildings, some rather down-at-heel. Dunster Street is at its best in summer, when the red and the cream glitter under blue skies. Indeed, basking in the sun on an August afternoon, the street positively dozes. It's a perfect place for a daydream.

Will Arnold's Henry Street factory has a problem. With brother Matt still finishing his liquid lunch up at the White Elephant, Will's on the case himself, driving down Overstone Road to Dunster Street, the engine burbling uncertainly, but then a Morris of 1920 can hardly be expected not to show its age a little in 1925. Dunster Street comes up on his left, with two factories, like imposing guards, either side. He passes between them and pulls up at once on the right, in front of the tall Globe Leather Works. The street before him lies empty, but, with the engine switched off, all is far from silent. Most of the noise comes from the curriers across the road where ready-tanned leather, waiting to be dressed, is being delivered. From the open ground-floor windows, too, comes the sound of slurping water, as hides are soaked and washed; instructions are shouted from the middle floor, where there's sorting going on; and groans are grunted from the wooden louvered windows of the drying rooms on high, where hides are being hung from hooks in the rafters. Will likes Globe Leather's boss, the successful Jim Collier's son, and has always been a little envious of the building's decorative frontage. It is neo-Jacobean apparently.

As he goes into the Globe works to discuss his needs, all the way down the southern side of Dunster Street workers press quietly on with familiar tasks, dreaming of closing time: In Morris's, the leather factory, at Nos 36–42; in Moss's, the foul-smelling leather offal business, at No. 54; in Bill Evans' subcontracted closing rooms at Nos 56–58, where uppers are being sewn by women in a trance; in Pearsons', the ink manufacturer, at No. 60, and the Richard Davies Leather Co., the furthest down the road but always worth a visit, at Nos 62–64. It's thirsty work on a summer's day. And when at last the bells start ringing to sound release and workers appear in droves, streaming along the pavements and noisily gulping in the pure fresh air, there's good business being done across the road at No. 35, where jovial John George dispenses bottled beers.

Will Arnold, his crisis solved, does a cautious five-point turn. He burbles uncertainly back to Henry Street, where the Morris, resting under the shadow of Arnold Brothers, exudes meaningful steam. Memo for brother Matt: get a good part-exchange deal. . .

Dunster Street's former tannery with louvred windows imaginatively modified.

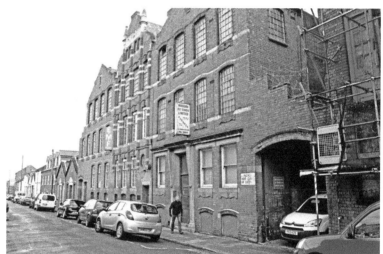

The former Globe Leather Works in Dunster Street.

# 18. Dynamic Derngate

Cynics have suggested that the creation of 'The Royal & Derngate' as a single entertainment complex was rather like a shotgun marriage between Beauty and the Beast – a delicate Victorian damsel given into the all-enveloping clutches of a 1983 monster (sired by a bus station). But that is to ignore the Victorian warehouse on the Guildhall Road that fronts up the new building with considerable aplomb, once owned by Phipps & Son, a wholesale shoe mercers. There was also a big makeover of 2006 that helpfully maximised the monster's performance and recreation spaces. Indeed, through the heroic efforts of his minders over the last few years (and, no doubt the charming influence of his Royal consort), he has become so delightfully amenable and

welcoming that an evening (or matinée) spent in his lair is guaranteed to be delightful. He should be congratulated for opening up his premises in the daytime and reaching out to the community with the kind of courageously wide programming that the centre's originators must have envisaged in their dreams.

Since 2006 the Derngate has been the home of the annual Malcolm Arnold Festival. There, for one gloriously hectic weekend of music-making, the town's much-loved, rainbow-coloured monster demonstrates his outstanding qualities of friendliness and flexibility.

The Derngate Centre looking down newly modernised Swan Street.

# 19. East Park Education

East Park Parade looks out commandingly across the racecourse, a tall and elegant terrace of the 1880s, taking its name from the parade ring nearby. In 1886, when No. 37 began life as a school, the excitement would have been considerable on race days, but these were a thing of the past when, in 1925, Robert Phillips moved into the adjacent No. 38 as the new Eaglehurst College headmaster. Organist at St Michael's Church and a future vice president of the county cricket club, he was to be succeeded in the fullness of time by his son Ian, a good enough cricketer to play for the county, affectionately nicknamed 'Bush' for his distinctive moustache. 'Bush' would run Eaglehurst with much distinction right up until its eventual closure in 1977. Somehow, in its boom years, its somewhat stark and distinctly limited classrooms catered for 100 pupils up to the age of thirteen.

For many years, then, East Park Parade was aglow in term time with the Eaglehurst blazers of cherry-red and navy-blue stripes, on which were proudly emblazoned the badge of an eagle, wings outstretched ready to soar. One of the colourful, milling throng, however, who was not particularly keen to soar, or, indeed, to be in East Park Parade at all, was Malcolm Arnold, who first arrived there in 1927 at the age of six. Naturally headstrong and rebellious, and terribly spoilt by his adoring mother, he was hardly propitious Eaglehurst material, but his Uncle Matt happened to live next door, at No. 36, and Malcolm's father Will had heard of its excellent discipline. It was, thought Will, just what his worryingly recalcitrant youngest son most needed, if one day he was to play his part in the all-important business of helping Arnold Brothers to new heights.

Malcolm's schooldays usually began with the family chauffeur being diverted to the very best sweet shops so that Malcolm, always extremely generous, could dispense largesse to all and sundry. Unfortunately his extrovert behaviour soon made his position at the school somewhat tenuous, and, though it helped that one of his very best friends was the headmaster's son Ian, he spent periods away at the Town and County Grammar School and the Miss Stricklands (of No. 18 Billing Road). On and off, however, he somehow managed to spend five years in Eaglehurst colours. And it was there that his formal education ended, for although his native wit ensured he

passed the entrance exam to Mill Hill, he only spent four hours at the school before summoning his friend, the chauffeur. Northampton, with a music shop here and a cinema there, could happily prepare him for his future.

Malcolm made a sudden return to East Park Parade in 1936. A talented young musician, Philip Pfaff, had moved there after his appointment as organist and choirmaster at St Matthew's. Malcolm was a naturally gifted instrumentalist and with Pfaff's inspiring tutorship he won a scholarship to the Royal College of Music that opened up a whole new life.

Eaglehurst College's former premises in East Park Parade.

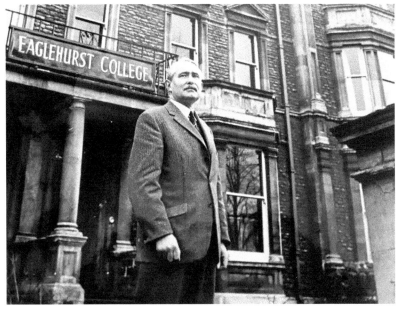

Headmaster Ian Phillips at Eaglehurst.

# 20. Elegant Escapees

The Market Square's Welsh House and Mare Fair's Hazelrigg House are two elegant buildings that miraculously escaped the Great Fire of 1675 and the great mayhem of the 1960s and 1970s. Welsh House (1595) at one moment was earmarked for destruction in 1975 to make way for the Grosvenor Centre. Instead, it enjoyed a last-minute reprieve that not only meant escape from the bulldozers but an expensive makeover that stripped it of its Victorian alterations and gloriously restored it to its original Elizabethan form. The Welsh inscription on its façade, from which the house takes its name, seems very apt: 'Without God you're in trouble but with God you're secure'. And so, today, it sits securely beside the Grosvenor Centre, like a lamb with a lion, its somewhat more compatible neighbour on the other side being the attractive seventeenth-century Beethoven House. Rumours that the great Ludwig once spent a night there are apparently unfounded.

There is a possibility, however, that Oliver Cromwell may have slept in an early form of Hazelrigg House, the second of the elegant escapees. This would have been before the Battle of Naseby in 1645, and, as the earliest recorded date of anyone living in the house is around 1620, the claim has some credibility. The house acquired its name from its long association with the Hazelrigg family (originally Hesilrige) who also purchased the castle in 1662. It has been owned since 1980 by the Borough Council. Its elegant façade is now faced and overshadowed by a giant of a building, the Sol/Vue complex of 2002, inspired, apparently, by Milton Keynes' Xscape.

Hazelrigg House.

# 21. Elgar's Elwes

Northampton-born Gervase Elwes was Edwardian Britain's outstanding tenor, although he was already thirty-seven when, in 1903, he turned professional. As the future squire of Great Billing, such a career was unacceptable. But when his father eventually withdrew his opposition, he made an immediate hit in one of the very first performances of Elgar's *The Dream of Gerontius* and thereafter the country's leading composer was a faithful fan. Elwes excelled in all the great religious masterpieces, like Bach's *St Matthew Passion*, and soon the top song writers of the day, from Vaughan Williams to Roger Quilter, were seeking him out for their premieres. He had a special something. Henry Wood, the founder of the Proms, spoke of 'a beauty of spirit and a beauty of execution that raised all his performances above the things of this earth'.

When Gervase Elwes inherited Billing Hall in 1908, he had to cope with a crumbling three-storey Georgian mansion beset with heavy mortgages, encumbered lands and crippling death and estate duties. Undaunted, he set in progress a full restoration, even uncovering in the process some handsome Jacobean features. Alas for these initiatives, Billing Hall was destined to pass out of the family's hands and be demolished in the 1950s 'for no particular reason'. Glimpses of it, however, survive in Winefride Elwes' memorial biography of her husband. She describes, for example, how, well before her marriage, she and her family paid a visit there:

> In the summer of 1888 it was decided to celebrate Gervase's coming-of-age. We were all highly excited at the prospect of seeing for the first time the home which he had so often and so enthusiastically described. Arriving at Northampton Station, we were met by Gervase with the big family barouche painted a vivid canary yellow and drawn by a pair of horses. Half-way to Billing we came to a perfectly hideous house, reflecting the pseudo-Venetian inspiration of Ruskin in its most garish form, fronting the main road. 'Here we are,' said Gervase, pointing at this abortion, but we were only momentarily deceived. Half a mile further on our first view of Billing thrilled us, covered with wistaria blossom and standing surrounded by its glorious trees, with rolling lawns running down to the string of ponds in the foreground; a view that I was to know and love well for many happy years.

Great Billing, now part of Northampton, still retains much of its village atmosphere and there are several reminders of Elgar's favourite tenor: the sixteenth-century pub, the Elwes Arms, with the singer's portrait on its sign; an eye-catching little Catholic church, created in his boyhood when the family converted to Catholicism, whose choir he later trained and regularly led at Sunday Mass; a bronze bas relief, set up 'in grateful memory of a beloved Squire'; and Elwes Way and Lady Winefride's Walk, both leading to St Andrew's Church, beside which, in the Catholic burial ground, an impressively tall cross marks the site of Elwes' grave. There, in January 1921, his six sons had carried his bier to its last resting place, as the gathered family sang

the Gregorian setting of 'In Paradisum'. He had died, aged fifty-five and still at the height of his powers, in a tragic accident at a Boston Railway Station during singing engagements in the USA. Elgar summed up the grief enveloping the nation: 'My personal loss is greater than I can bear to think upon, but this is nothing compared to the general artistic loss – a gap impossible to fill – in the musical world.'

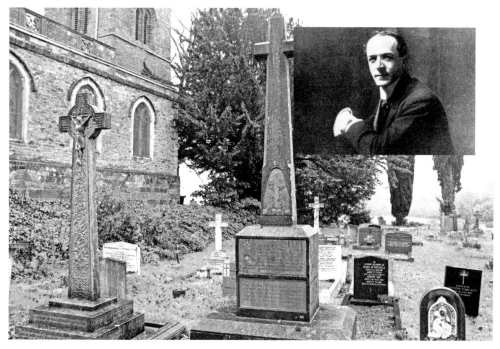

Gervase Elwes' grave (centre) in the Catholic churchyard.

The Elwes church in Great Billing.

# 22. Fame and Mr Franklin

Franklin's Gardens, the rugby football ground that is home to the famous Saints, commemorates a Northampton newspaper editor and entrepreneur, James Campbell Franklin. Strangely, Franklin's association with the Victorian pleasure gardens he owned to the west of the town only lasted two years (1886–88). First created in the 1860s, they were known initially as the Melbourne Gardens. Then Franklin acquired them and named them after himself. He introduced some new entertainments like trapeze acts and balloon ascents, but it was the next owners, the Northampton Brewery Co., who more than tripled the gardens' 10 acres, enlarged their zoo and monkey house, and gave them a lake and any manner of sports facilities including,

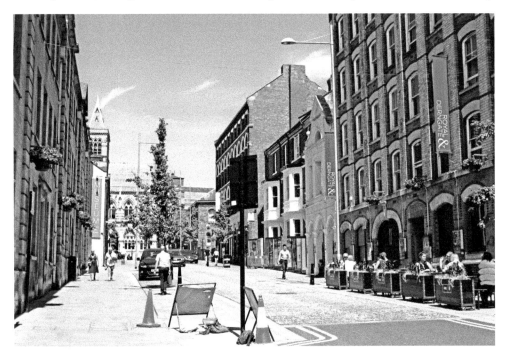

Beyond the Royal & Derngate: the tall (former) Franklin's Hotel.

in the late 1880s, a ground for the Saints. That they remained, in name, Franklin's Gardens shows something of the entrepreneur's standing in late Victorian times. He owned a big hotel at No. 9 Guildhall Road that was long known as Franklin's Hotel (and is currently starting a new life as a contemporary art centre). He also built and ran the Royal Theatre for a short time. After his death his widow donated a fine reredos in his memory to St Edmund's (pulled down in 1980). But, in the end, it is the two-year tenure of some pleasure gardens that Franklin neither founded nor fully developed for which his name is still remembered.

# 23. Film Favourite Flynn

Fifty years after Mr Franklin founded the Royal, Errol Flynn joined the repertory company there for the 1933/4 season. At twenty-four he had the strikingly handsome features that would cause the world to swoon. His huge Hollywood salaries, however, were yet to come – £5 a week was all he earned as a young beginner starting out in Rep, barely enough for his rented rooms in Hazelwood Road. But this didn't stop his roistering in The Mailcoach (then called The Swan), and his flamboyant ways were already causing a stir. 'He was a real ladies' man,' remembered a Rep colleague. 'Of course that's good for the theatre because he drew in the crowds. His acting sometimes left a lot to be desired but they used to crowd round the stage door and ask for autographs.' Apart from playing a prince in *Jack and the Beanstalk*, he was usually given minor roles. Freda Jackson (who played Desdemona to his Ludovico in *Othello*) commented:

> He was not an intellectual man, but he was very shrewd. He knew that his supreme good looks were not enough to get him where he wanted to go, so he came to Northampton to learn his job. He did learn a lot from us, including how to walk across the stage without looking like something out of a zoo. When he left, he did so in a cloud of unpleasantness after hitting the stage manager, who was a woman.

Years later, in 1954, Flynn's fans flocked to Franklin's Gardens when he appeared there in a fundraising venture. Freda Jackson also participated. 'I almost didn't recognise him. He had lost his good looks by then, and it was hardly surprising when you consider the life he had led.' It was on this visit that Montague Jeffery Ltd supplied him with some suits, for which, alas, he never paid. Two superb little cinemas now honour the famous film star, only yards from the outfitters he somehow managed to forget.

# 24. Glendinning's Discovery

Since 2005 Lucy Glendinning's sculpture *Discovery* has dramatically straddled the Abington Street pedestrian precinct, celebrating Northampton-born Francis Crick, a Nobel Prize winner and the co-discoverer, back in 1953, of the identification of the structure of DNA. Human understanding of the make-up of life might well be less advanced had this celebrated scientist devoted himself to the family's Northampton boot-and-shoe factory, Crick & Co, founded on St Giles' Street by his grandfather, Walter Drawbridge Crick.

There's a strong scientific raison d'être behind *Discovery*'s two identical life-size figures of marble resin that seem to be flying away from long, curved plinths. According to their creator, they 'echo the shape of the double helix, the balances of energies that bind it, and its function, the formation of life'. Though this may elude the average observer, the power of the piece cannot but make an impact. 'I've used the figures,' explains Lucy Glendinning, 'in bold, abandoned postures to convey a sense of his optimism and passion and the sheer daring of Francis Crick's work.' She certainly succeeds.

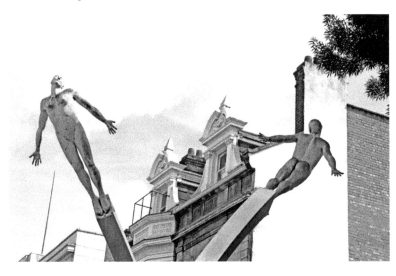

Glendinning's
Discovery.

# 25. Godwin's Gothic Glory

It is difficult to believe that in the 1950s, when the Victorian style of Gothic Revival was generally scorned, the superb Guildhall was nearly lost. Fortunately common sense prevailed, and today, of course, the name of its architect, E. W. Godwin, is revered. Ernest Reynolds is typically appreciative:

> With a touch of Venetian Gothic so beloved of Ruskin, and the flavouring of the flamboyance of a French medieval cathedral, the building is yet essentially English in its composition. Illuminated clock tower, arched and vaulted council chamber and serried rows of beautifully sculptured windows combine to produce an effect of solemn and yet comfortable-looking grandeur which is well in keeping with our national tradition.

Though Godwin understandably gets most of the credit, he was, in fact, responsible only for the right-hand side of the building, a satisfying entity in itself centred on the clock tower and mayoral balcony and dating to 1864. Matthew Holding's wonderfully sympathetic extension of 1892 added the left-hand section (the seven bays on the ground floor with six windows above). This addition, wrote Reynolds, 'transmuted the original design into a creation of pure genius, galvanizing the somewhat too formal Ruskinesque main portion into a beautiful flowing harmonious composition, rich, splendid and at the same time balanced and serene'.

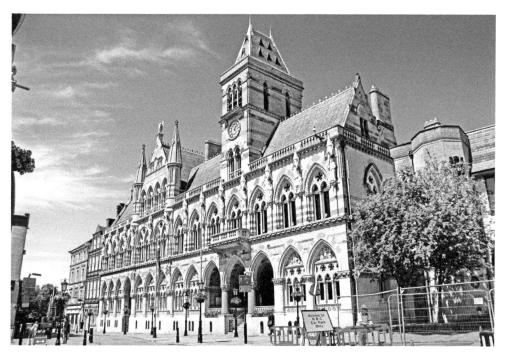

The Godwin-Holding Guildhall.

That the concept is theatrical is unsurprising. The theatre was Godwin's passion. A leading aesthete and close friend of Oscar Wilde and James McNeill Whistler, Edward William Godwin (1833–86) was at the very forefront of theatre and furniture design of the 1870s and 1880s as well as a figure of considerable notoriety as the lover of the great actress Ellen Terry and father of her two illegitimate children, one of whom was Edward Gordon Craig. Godwin was still a young man when he won the Northampton Town Hall competition. Other early works of his in the town include the doomed 'Rheinfelden' (whose 'pseudo-Venetian inspiration of Ruskin' was mocked by Gervase and Winefride Elwes); the less flamboyant but equally outstanding St Martin's Villas, surviving at Nos 43–44 Billing Road; 'Elmleigh' at Dallington, resplendent in golden stone; the unusual walls of the kitchen garden at nearby Castle Ashby; and the turreted station lodge on the Earls Barton side of that estate.

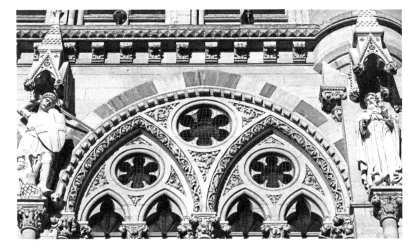

Guildhall detail: St George and St Patrick.

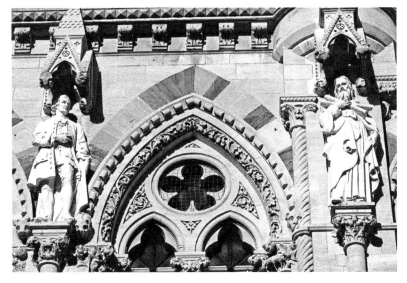

Guildhall detail: local poet John Dryden in the heady company of St Andrew.

# H

## 26. Harmonious Holding

Matthew Henry Holding (1846–1910) was an architect of outstanding quality, a 'genius' according to John Betjeman, even though he rarely worked outside the county. The son of a prosperous Northampton builder, he was brought up at No. 50 Abington Street and trained as an architect in London. His wife, Edith de Wilde, by whom he had seven children, came from a notable Northampton family. Her father was a long-serving editor of the *Northampton Mercury* and her grandfather was the well-known portrait painter George James de Wilde. They began married life at No. 10 Cyril Street, close to St Edmund's Church where Holding was a devoted lay reader and churchwarden. As business boomed, they moved to the Regency delights of No. 5 Spencer Parade.

Holding worked from offices in the Market Square, first at No. 18, then No. 1 (Victoria House) and finally the Corn Exchange. His reputation was made with some splendid churches, notably St Mary's (1885) on the Towcester Road with its most perfect of interiors: 'The lovely roof and superb treatment of the apse with vaulting and stone ribbing,' wrote Ernest Reynolds, 'suggests a medieval monastic chapel, dignified and yet intimate.' Sadly, St Crispin's and St Paul's have both been pulled down. There are two imposing examples, however, of his early, red-brick town houses: the 'Carolean' terrace at the far end of St Giles' Street and the 'light-hearted Jacobean' Addison Villas of Nos 34–38 Billing Road.

The successful Guildhall commission (1889–92) meant Harding was much in demand ever after. He designed several distinguished buildings in the Phippsville and Wantage estates that he helped mastermind and had a virtual monopoly of church reconstruction work around the county. His two finest works, both masterpieces in their different ways, were St Matthew's Church (1891–94) and the Abington Park Hotel (1898). 'The Abington' is a gloriously extrovert, French Renaissance showpiece, boasting silver-grey dressings, stylish chimneys, fine carvings and a delightful porch. Its sign outside, until quite recently, depicted the bearded architect. St Matthew's is more characteristic, wonderfully decorative inside and out, but with no fussiness. Ernest Reynolds loved the eastern view of its exterior:

Especially in the early morning with the sun making a glittering fire of the windows in the apse and the Lady Chapel, and the lofty spire, with its golden weather vane, rising up behind... The entire ensemble is a beautiful essay in colour – brown stone, white spire, red roof, grey fleche, gold vane.

John Betjeman, when preaching there, picked out the harmonious proportions of the interior, 'its soaring vistas of pale stone arches' and 'the lacelike tracery of the beautiful wrought-iron chancel screen.'

Holding was joined in his practice by his son Edward, who completed the beautifully windowed Holy Trinity Church, Kingsthorpe, and tried hard to solve the problems of Christ Church, Abington (which now has a strikingly modernized west end). After illness forced his father's retirement in 1909, Edward took over the practice. Matthew Holding died a year later, large crowds attending his funeral at St Giles. He was buried in the family grave, overlooked by his old home.

A kind and philanthropic man, Holding had a lively sense of humour. All the architects in the Guildhall competition had to be anonymous, calling themselves by a fictitious title. He cheekily chose 'Victurus', the Latin for 'the man about to win'.

Holding's St Matthew's Church.

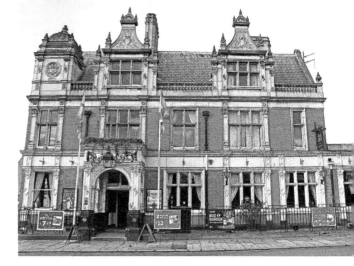

Holding's Abington Park Hotel.

Holding's 'Carolean' charisma: terraced houses at the end of St Giles' Street.

Holding's grave in St Giles' churchyard.

# 27. Henry Street Highlights

The Arnold Brothers' first factory, in Henry Street, had already passed through several hands before it was acquired from Eyre Brothers in 1909. In its way it was a model factory, with Will a much-respected boss in charge of sales and administration, but also keeping an eye on brother Matt's design and production brief. He knew each of his several hundred employees by name and was actively involved in their welfare.

The factory's old and no longer valid address (No. 50 Henry Street) can cause confusion. Will and Matt's building is currently serving as a warehouse for Bengal Foods, with a dance school above, and is situated just a few yards (in the Kettering Road direction) from the entrance to St Michael's Mount. It faces directly onto the back of some of that road's gardens. Though rundown and weather-worn, it has a strong presence, its single stone pediment being its most distinctive feature. Just beneath, framed by carved pilasters, is the large wooden 'taking in' door for heavy goods winched up by crane.

Following his father's example at St Giles' Terrace, Will was soon acquiring land behind the factory, and beside it too. Next door to Bengal Foods is a metal-welding business, Favell Fabrications, housed in the one-storey extension that was built for Arnold Brothers. Though squat and narrow, it stretched back a considerable distance. Much more impressive was the acquisition of another whole factory with a frontage in Talbot Road, conveniently parallel with the Henry Street plant. Its acquisition allowed Will to incorporate all the ground between the two factories into one large complex. The central pediment reveals it was created in 1889 for the Normal Boot & Shoe Co. It has now been restored and converted into flats.

There are other buildings in Henry Street that were once a significant part of Will's world: the factory at the very far end was a leather merchant's, J. T. Meadows; next door to Arnold Brothers, a building inscribed 'Wholesale Warehouse 1890' and its three-storey extension (both currently used for offices) housed the Queen's Boot Co., run by John Branch, Will's rival and neighbour; and towards the Kettering Road the 'Top Boot' apartment conversion marks the premises of another old friend, shoe manufacturer Charles Smith. Mount Pleasant Baptist Church, staring down the street from the Kettering Road, also has significance. Will would sometimes preach there, and when he died in December 1978 at the age of ninety-two, it hosted his funeral.

Arnold Brothers' headquarters in Henry Street.

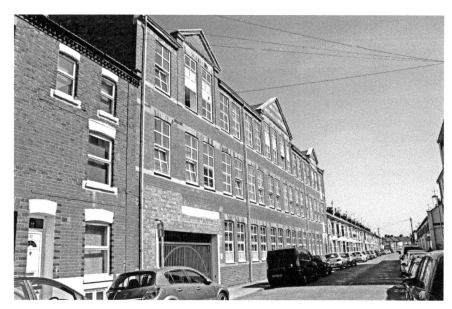

Arnold Brothers in Talbot Road.

# 28. Historic Hawkins

The boarded-up and derelict G. T. Hawkins factory in St Michael's Road has been a dispiriting sight. Hawkins was a firm of 120 years' standing. It had enjoyed royal approval, its riding boots being not only worn by Queen Victoria but also by Princess Anne when competing in the Montreal Olympics. Hawkins shod pilots in both the First and Second World Wars and generations of soldiers, from the Boer War to the Falklands. When Hillary and Tenzing scaled Everest in that famous expedition of 1953, they too were fitted out with Hawkins' footwear. So there was great rejoicing in 2016 when the future of this important factory was positively resolved.

George Thomas Hawkins (1857–1929), who lived many years at The Rowans, Cliftonville, was one of Will Arnold's mentors. Both came from working-class backgrounds. George, the son of a currier, had been a 'sticking boy' at seven and a 'clicker' at twelve, before signing on at Manfield's. Quiet and unassuming, at twenty-six he started his own firm in a very small way but, only three years later, he had his own premises at the end of Overstone Road. The acquisition of the adjacent Hornby and West factory in St Michael's Road duly followed. Walking boots were one of the firm's specialities, as the brand name Waulkerz suggests (it can still be seen inscribed over the door in Overstone Road). He also pioneered unusual sporting brands like 'the Demon Ventilated Tennis Shoe'. By 1914 Hawkins was among the town's top ten 'elite' manufacturers and so he stayed.

He retired from business life in 1920 with heart trouble, cultivating orchids at The Rowans instead. His son chose not to follow into the firm, and it was taken forward, on his death, by fellow directors.

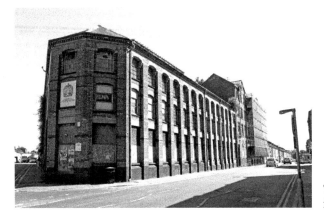

The sun sets on the élite Hawkins factory, St Michael's Road.

Industrial heritage at risk: the Hawkins factory.

# 29. Histrionic Henry

Easily recognisable in the town for his large felt hat and flamboyant clothes, Henry Bird (1908–2000) exuded artistic temperament. A highly talented artist, he was long an institution at the Northampton School of Art, where the flying sparks were legendary. 'Henry regarded talent as an obligation,' wrote his obituarist Ian Mayes in *The Guardian*, 'and he served his own with exemplary devotion. He could not understand people who appeared to take art less seriously.' He had a studio in George Row in an attic above the Northampton & County Club. Approached by a secret staircase, up which many a model came to pose, and illumined by a skylight through which the tower and cupola of All Saints' could be glimpsed, it was said to have brought a touch of *La Bohème* to Northampton. In addition to his drawings from life, Henry Bird was also a fine painter of murals. *The Muses Contemplating Northampton* can be seen in the Guildhall. His all-enveloping images in Denton Church should not be missed.

Born in Northampton in difficult circumstances, son of an impecunious baker who committed suicide, Bird had to fight hard to make his way. A scene painter and

set designer in London for a while, in 1950 he married the gifted West End actress and film star Freda Jackson, who was also a serious artist. Henry and Freda were soon the talk of Northampton. They had much in common. Daughter of a railway porter, Freda had had an equally hard road to success. They could be a formidable couple, as Ian Mayes related:

> Both of them tended to disdain small talk. Taking a chair between them in Hardingstone House, their home on the edge of Northampton, could be a bit like sitting on the anvil while the blacksmith was at work. It was a testing experience... They were devoted to each other – even if the relationship sometimes seemed to outsiders perplexingly antagonistic.

In 1978, when Bird painted the Safety Curtain (or, as he preferred to call it, the *Sipario Dipinto*) that is still in use at the Royal Theatre, he quietly included among many portraits his wife looking across towards Errol Flynn. When Freda had made her professional debut, in rep at the Royal in 1934, the company had also included the roving-eyed Flynn, 'with whom,' wrote Ian Mayes, 'Freda was reputed to have had a relationship. Indeed, Freda is said to have remarked, as a joke, that she chose Henry because he was so plain and unlikely to be lured away from her by another woman.' The story also goes that when Henry first set eyes on Freda, she was playing a witch in *Macbeth* with a lurid green face. 'That's the woman for me,' he is said to have cried decisively.

# 30. Homely Homestead Way

A modest little road running behind St George's Avenue, Homestead Way offers insights into three generations of the Arnolds. At one end is the very attractive Methodist Homestead, built in 1929 to offer 'Peace at Eventide for those who have served Christ and his Church' and largely funded by William Arnold Snr. He was living nearby at No. 26 Kingsley Road and, as a Liberal councillor and vice president of the Primitive Methodist Conference, fully identified with the role of the public-spirited and philanthropic shoe baron. His philanthropy would shortly extend to the funding of the Park Street Methodist Church (notable for its 'toothpick' spire) in memory of his first wife.

In strong contrast, on the other side of the road, at No. 5, we have a glimpse of his son Will in old age. The house we are looking for is a narrow one, next door to Homestead Court. Once called 'Restawyle', it comes in two connected parts – two little face-to-face bungalows or bunkers, their roofs sloping down towards each other, their backs set firmly against the rest of the world – specially built for Will in 1973 at the bottom of the garden of his former home. 'Restawyle' seems an extraordinary last resting place for a shoe baron, a kind of miniature bastion against infirmity and old age, raised perhaps in the hope that even death itself might forget to come knocking. For five years it housed a *ménage a deux* for the widower Will and his faithful housekeeper and carer,

Lizzie Witts, whose service with the Arnolds went back to the early Cliftonville days. It was all paid for by Malcolm, the only surviving son. Will was no longer in funds.

But when the going had been good, he had been generous. Our third calling place is No. 8, the semi-detached house that Will had bought not long after the Second World War for his high-spirited and sometimes wayward son, Clifford (1915–61), who was badly shocked by his experiences in the Merchant Navy on Arctic convoys. For a time Clifford traded from Homestead Way in sporty second-hand cars, advertising in the back pages of *Motor Sport*. The photograph shows him outside No. 8 in one of the most desirable of all vintage sports cars, a 1928 supercharged 36/220 Mercedes. We know from the number plate that this actual car was later acquired by Peter Ustinov and today, fully restored, it is on display at the Beaulieu Motor Museum. 'It was very, very fast,' remembered Ustinov, 'and had cable-operated brakes. When it rained, the brake pedal sent a message to one of the wheels, which rather reluctantly sent a message to another wheel, and so forth. Each wheel reacted at a different time so you were all over the road at 100 mph.' Clifford may not necessarily have made any money out of it, but he would certainly have had some fun.

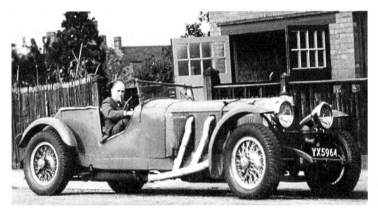

Clifford Arnold, part-time sports car dealer, in a 1928 Mercedes.

Methodist Homestead, Homestead Way.

# I

## 31. Ixion's Two Wheels

Basil Davies (1879–1961) was both a motorcycle sport pioneer and the young vicar of the Church of the Holy Sepulchre, who somehow was able to take off all the time he needed for events like the Six-Day Scottish Trial and the TT Races on the Isle of Man. Nor would 'St Sep's' on most of these occasions have been able to call upon his curate, for the Revd Percy Bischoff was as smitten with the lure of speed as his vicar, the two of them competing together all over the country and no doubt hatching sermons as they prepared their machinery in a garage near the church. The vicar's American wife, Frances, was clearly a good sport too. She looks demure, sitting in her sidecar beside the equally nonchalant Basil, sharing the very latest product from Louise Road's Advance Motor Manufacturing Co.

   What nobody in the parish ever knew during Basil's ministry at the Church of the Holy Sepulchre (1911–16) was that he was also a talented journalist. From 1903 he began writing for motorcycle magazines, using the nom-de-plume of Ixion (a quiet joke, for Ixion was a malefactor in classical mythology who ended up with the punishment of being eternally tied to a flaming wheel). Ixion soon became one of the leading writers in the motorcycle world. Several books followed that later became classics. Ixion's torrent of words lasted, in all, over sixty years, well after Basil Davies' eventual retirement from active ministry. It was only on his death in 1961 that his secret life as Ixion was finally revealed.

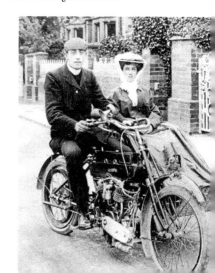

The Revd and Mrs Basil Davies, St George's Avenue.

# 32. Jewel from Jerusalem

The architectural jewel in Northampton's crown, the circular Church of the Holy Sepulchre, once lay just inside the north gate of the medieval town. It was built in yellow ironstone for Simon de Senlis, the Norman grandee and creator of Northampton Castle, who participated in the very first crusade of all, a three-year struggle that ended in the recapture of Jerusalem. One year later, in 1100, he built the Church of the Holy Sepulchre as a thanksgiving for his safe return, carefully modelling it on the circular church of the same name in Jerusalem, revered for being on the site of the tomb where Jesus' body lay before the Resurrection. In succeeding centuries worshippers embellished and enlarged the church, most notably with a nave of more conventional size and a tower, but at its heart is the circular place of worship upon which the returning Norman grandee insisted.

The concentric interior fascinates. Eight huge Norman pillars dominate. The stillness is vibrant, the sense of past times deeply strong. It is alive with history, with centuries of living faith, with all that is best and most hopeful in uncertain times. The Church of the Holy Sepulchre ('St Sep's') is where Richard Coeur de Lion once prayed before the Second Crusade, an act of piety recently re-enacted in a moving production of *King John*, maximising the opportunities of the medieval surroundings. There he was again, lying on a stone sarcophagus as monks offered up plainsong and the air was filled with smoke from incense and candles – 'St Sep's' at a moment of deep inspiration.

The modern town appreciates the jewel in its midst. After a determined programme of restoration, finally completed in 2010 after nearly thirty years, the church is in its best condition for many centuries. But though the jewel glitters most brilliantly, it glitters away from view more often than not. It has to be a deep disappointment that its doors are shut except for services and a couple of afternoons for a few months each year. Of course it's a national problem. And 'St Sep's', it must be said, is slightly more open than the average church these days, so deep the sense of siege that has been created across the country from past experiences. But churches need open doors. Sieges can be lifted. Richard Coeur de Lion did not have to look in his diary or consult a website to find out whether or not he could pray in the Church of the Holy Sepulchre.

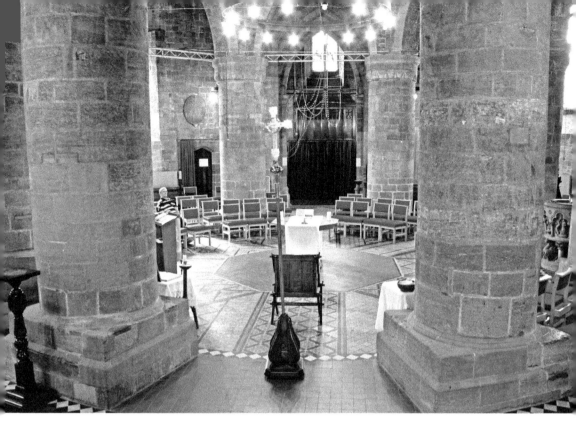

The Church of the Holy Sepulchre.

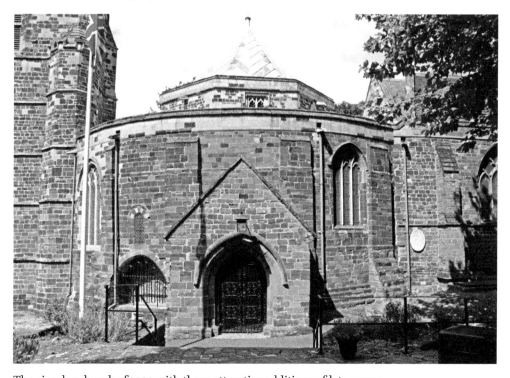

The circular church of 1100 with three attractive additions of later years.

# 33. Keen King John

King John was keen on Northampton. He is known to have visited at least thirty times, staying, of course, at the best suite in the castle, on which he lavished large sums. In 1205 he moved his treasury there, associating Northampton with the royal mint. In 1213 he showed his keenness another way, becoming the first known person to buy a pair of boots from the town, paying the kingly sum of 9*d*, but then they were large and heavy, possibly reaching to the thighs and for special equestrian use. (Esteemed very early for its shoemakers, Northampton also supplied shoes to Edward I.) King John was in the castle when it withstood a siege by his barons and, shortly after he signed the Magna Carta, it was one of four castles seized by the barons as a guarantee that he would keep to its terms.

Northampton's castle plays a key part in Shakespeare's *King John*, not least in that famous dramatic highlight when the king's nephew, Prince Arthur, jumps down the walls to his death:

> The wall is high and yet will I leap down.
> Good ground, be pitiful and hurt me not. . .
> O me! My uncle's spirit's in these stones.
> Heav'n take my soul, and England keep my bones!

The great actor-manager Herbert Beerbohm Tree, whose productions in the early twentieth century were famous for their historical and archaeological exactitude, was so carried away by the Northampton connection in *King John* that he not only featured both the interior and exterior of the castle in his stunning version but also had an important scene in Act 5 played out in a beautiful reconstruction of the Church of the Holy Sepulchre.

*Right*: King John
(Sir Herbert Beerbohm
Tree).

*Below*: Northampton
Castle in Beerbohm
Tree's *King John*.

# 34. Law's Lasting Legacy

Edmund Francis Law (1810–82) was more than just a very fine architect. He was a pillar of the community, a rich, 'hard fighting' and long-serving Conservative town councillor who rose to become mayor; a Justice of the Peace who was also the borough surveyor and superintendent of the All Saints' Sunday schools; a man of such strong commitment that, though mortally ill, he insisted on opening a new Mission Room in Gregory Street. He was regarded as 'the poor man's friend' and on his death the whole town seemed in mourning, the pavements between All Saints' (where his funeral was held) and St Giles' (where he was buried) being thickly lined, the shops closed for business.

There was particularly identified with church restoration work. Sadly, the finest church in the town of his own design, St Andrew's, was pulled down in the 1970s. Happily, there's a solid legacy of Law's secular buildings. Along with the Palladian purity of the National Westminster Bank in the Drapery and the mock-Tudor Abington Cottages, there is much 'Gothic revival' dexterity: Alfred Church's home on Cheyne Walk, James Franklin's former hotel at No. 9 Guildhall Road, the Weights and Measures house in St Giles' Street, and Becket and Sargeant's School for Girls at the top of Kingswell Street.

There's a confidence about all his work that reflects a man moving in high places. Among his close friends were Sir Henry Dryden, owner of Castle Ashby, Pickering Phipps, the brewery magnate, and George Gilbert Scott, the leading Victorian architect. Portraits of Law in his mayoral robes, when reaching fifty, give little away. There's a touch of Omar Sharif about him. He's clean-shaven, with a mass of well-groomed dark hair just beginning to be streaked with grey. There are signs, under his eyes, that he worked late hours. It seems there was a warm personality beneath the serious public figure. One of his students remarked on the great contrast between his 'very dry' talks at Gold Street's lecture hall and the 'hospitality and wit' he showed when entertaining at his Wood Street home. His many generous bequests to the town included one of his most prized paintings, Grimshaw's portrait of John Clare. Law himself was a sensitive and talented watercolourist, spending much of his leisure responding to the beauty of the surrounding countryside, as in his wintry scene, *On the Nene, near Elton*, on display in the museum. On his deathbed in 1882 he had requested that his favourite horse, a striking bay, might be included in the team of six that pulled his coffin to its last resting place . . .

All Saints' was Edmund Law's own parish church as well as one of the many on which he had worked. In 1884 his son Edmund, who was to carry on his father's practice for over twenty years from No. 29 Abington Street, represented his father when, in his memory, the All Saints' organ was repositioned on the north side of the chancel and given its own special 'chamber'. Later, in 1888, Edmund Law Jr completely remodelled the chancel. His father would have much approved.

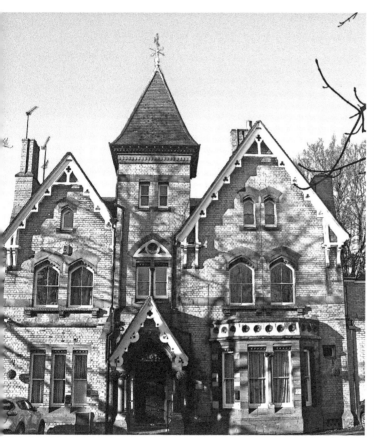

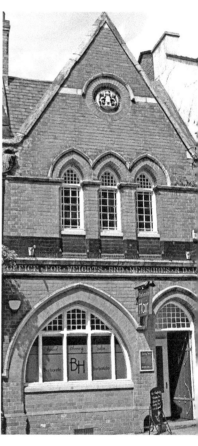

*Above left*: Law's Cheyne Walk Club, once Alfred Church's home.

*Above right*: Law's Weights & Measures building, St Giles' Street.

*Right*: Law's seating redesign in All Saints', part of his 1860s alterations.

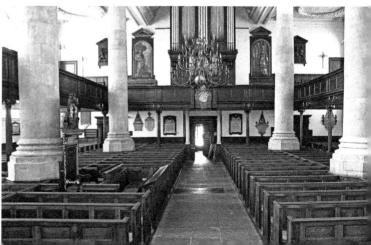

# 35. Manfield Memories

Sir Moses Philip Manfield (1819–99) was one of the earliest shoe barons. A whistle-stop tour of buildings provoking Manfield memories will give us four quick insights into the great man.

Our first stop is Manfield's headquarters at Campbell Square (most unfortunately demolished). Built ornately in 1856, a veritable palazzo that would not have seemed out of place on Venice's Grand Canal, it was also historically important as the town's first machine-based shoe factory, challenging the industry's long tradition of outworkers (like young Billy Arnold) who only met their boss to collect and return work done at home. We move on to Cliftonville to see Redlands, the house where Manfield lived and died. It survives, large and solid, classical rather than Gothic, shorn of some of its capacious grounds.

Our third stop is the Manfield factory of 1892 on the Wellingborough Road, once a vast complex, eliminating a 4-acre wood, Monks Park Spinney, its 600 workers (and 600 outworkers) soon producing a turnover of 350,000 pairs of shoes. It sprawled backwards in revolutionary single-storey mode, behind a wide and imposing red-brick 'Jacobean' frontage. The huge sprawl, of course, has now gone, but the frontage survives as a listed building, though put to other uses, for a series of takeovers began in the '50s, and Manfield continues today only as a brand name.

Finally, in Abington Square, we stop at the former Kettering Road Free Church, currently the All Nations Church, a gift from Manfield in 1896 to the Unitarians, the freethinkers whose financial support had helped him when he first arrived, as a fortune-seeking twenty-four-year-old.

We should perhaps have visited the Guildhall, for Manfield served as mayor, and the railway station, which he would have much used in later life as Northampton's MP. The arrival of this august businessman in the House of Commons encouraged *Punch* to have some gentle fun with his initials:

Northampton's new Member an honour can claim
On which he need set little store:
He now has MP written after his name,

But he always had MP before.
If every MP in the lobby counts one,
To the Ayes, or the Noes, walking through,
Does logic demand, in each case, pro and con,
MP Manfield MP should count two?

# 36. Milton Street Mystic

Ruth Arnold (1909–66), Malcolm's elder sister, shared much of his imagination. It came pouring out in art and poetry. But she also shared his mood swings, and her father Will, so often preoccupied with boots and shoes, found her volatile artistic temperament something of a trial. When her time at the Slade School of Art ended prematurely and explosively, he never truly forgave her. He would forgive Malcolm his youthful excesses when he became successful, but poor Ruth was always looked upon by her father as a failure, her creative gifts lost in a man's world and never having the tuition and encouragement they needed. Will hoped she'd marry a prosperous doctor, but in 1939, in response to all his pressure, she chose instead a trainee hairdresser of working-class background and, despite his name, Charles Dickens, limited prospects. Having failed his army medical, he spent much of the war on assembly lines at Crockett & Jones. They spent most of their married life in a council house, No. 128 Milton Street, which had shop premises attached, just right for a hairdresser.

Ruth's life was enlivened by a bohemian existence, fun with her two devoted daughters and local excursions in an elderly Riley. She regularly frequented dear Aggie Billingham's second-hand bookshop on Bridge Street. She was often backstage at the Royal Theatre, helping designer Tom Osborne Robinson painting sets. Other close friends included Henry Gascoigne, the gay dress designer who killed himself, and a jolly Catholic priest at Great Billing, with whom she would delightedly light candles and secretly partake of communion wine before retiring to the Elwes Arms. She was deeply serious too. A pervading mysticism led to a lifelong interest in the world of the spirit and the founding of the Spiritualist Church of Truth Seekers. But eventually she had to settle for the fact that the highly promising poetry and art were a thing of the past. Passionate in causes like feminism and gay rights well before their time, and afflicted with despair at an uncomprehending world, she would seek periods of respite in St Crispin's Hospital, and there she died, her talents largely unfulfilled. Yet such was the vitality of her chaotic and brave life that it has been chronicled in a short biography. One characteristic poem, which her brother Malcolm turned into a charming song, lives on:

Beauty haunts the woods at night.
O woods of stillness and delight!
Of things that love them, only I

Have wished to rest there, when I die.
Beauty and I go hand in hand
Through this green-foliate Fairy Land
And when I wither, this I crave –
That Pan will pipe upon my grave.

*Above*: A youthful self-portrait of Ruth Arnold.

*Right*: Ruth Arnold: bold colour and imagination.

# 37. Mobbs the Magnificent

With its first-class sporting facilities, Northampton has long produced great games players. Edgar Mobbs (1882–1917), born in Northampton, brought up in Olney and educated at Bedford Modern School, became an outstanding example, a star wing three-quarter who captained both Northampton Saints and England. At six foot one, with fair hair and blue eyes, he was a commanding figure. After club games with Olney, Weston Turks and Northampton Heathens, he played seven seasons with the Saints, from 1905–13, scoring an impressive 177 tries. He only had one thought in his head: attack! Tunnel-visioned in his belligerence, he was so famous for his solid hand offs that some opponents would wear protective headgear. He loved his rugby, played eight great games for England, also starring for the Barbarians, the East Midlands and Toulouse, and in the summers he was a formidable presence on many a cricket field. Forthright in word as well as deed, he had no time for the establishment and its bureaucracy. When the Rugby Football Union attempted to involve him in an investigation into professionalism in the Midlands, he soon gave them the hand off. His blunt criticisms of their poor treatment of the touring Springboks of 1912–13 was a typically forthright riposte.

Edgar Mobbs, commemorated in the Garden of Remembrance.

When war came in 1914, he gave up his job as sales-manager of the Pytchley Auto Car Co. at Market Harborough to enlist. Told that he was too old for a commission, he joined up as a private, raised his own unit of 264 fellow sportsmen (less than a third of whom would survive the war) and quickly made them part of the Northamptonshire Regiment's 7th Battalion. During training he threw himself into the organizing of rugby matches for war charities, turning out for the Barbarians as Captain Mobbs, raising large amounts of money and recruits. Soon he was sending from war-torn France postcards of himself handing-off German soldiers in typically belligerent style. He would sometimes punt a ball into No Man's Land before leading his men over the top. Wounded at the Battle of Loos in 1915, he still insisted, during recuperation in England, on representing England against Scotland in an exhibition match. Back in France in 1916 as a lieutenant-colonel, commanding the 7th Northants, he was wounded by shrapnel in an attack on the Somme (for which he won the DSO) and was wounded again in April 1917 during the Battle of Arras. Finally, in July 1917, having opted to lead an assault himself on two lines of trenches at Passchendaele, he last seen gallantly charging a machine-gun post. It was one handoff too many. His body was never found in the Flanders mud. He was thirty-five.

# 38. Much-missed Musketeer

Jonathan (Jonny) Ollivier (1977–2015) was at the peak of his profession when he was killed on his way by motorbike to dance in Matthew Bourne's *The Car Man* at Sadler's Wells. His death at thirty-eight was unthinkable. Few other dancers could project such power, virility and emotional intensity on stage. During his years as a principal with Northern Ballet he had excelled in passionate roles such as Heathcliff, Dracula and Stanley in *A Streetcar Named Desire*. As the lead in New Adventures' all-time hit, the male version of *Swan Lake*, he was supreme.

Jonny Ollivier had come up the hard way. Born in Northampton, he had been brought up in a single-parent family after his father had left when he was two. The key event of his life occurred when he was seven. Two of his sisters had been taking lessons at the Julie Fairweather Dance School. One day his mother needed to leave him there in a class, while she did some urgent shopping. He loved it and thereafter, having quickly decided that he wanted to be a dancer, attended lessons regularly until, as a sixteen-year-old Thomas Becket pupil, he qualified for the Rambert School of Ballet. Things, however, were still tough. He had to work at Heathrow Airport in the evenings and through the weekends to make ends meet, but his perseverance eventually paid off, leading to a professional contract. In rapid time he became a principal dancer.

Throughout his career he never forgot his Northampton roots, and in 2006 was delighted when the university made him an Honorary Fellow. By coincidence, it similarly honoured Malcolm Arnold, to whose music Jonny was about to dance as one of the three musketeers in Northern's new ballet of that name. 'Although Malcolm Arnold was elderly by then and too infirm to attend,' remembered Ollivier, 'I was really chuffed to get the fellowship at the same time as him. It made it really special.' Then came *The Three Musketeers*. 'We were shocked to learn just before the curtain went up on the opening night that Malcolm Arnold had suddenly died. The audience were told. It made all those anxious nerves go away. The occasion was too special. We knew what we were there for – to do a good show, a show that was to be in his honour.'

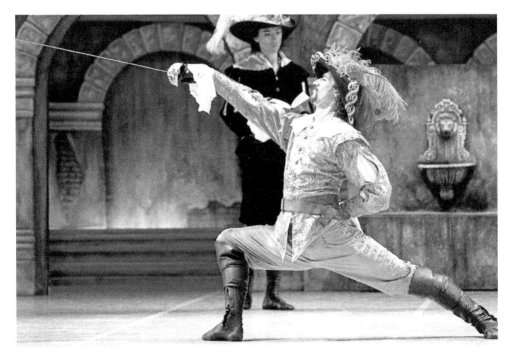

Jonathan Ollivier as Athos. (© Merlin Hendy 2006)

# N

## 39. New Theatre Nostalgia

There was a sense of outrage in Abington Street in 1912 as the demolition men moved in. The premises of poor Mr Broom, who ran Broom's Library so earnestly at No. 84, and smart Miss Law, the ever-helpful haberdasher at No. 86, had been compulsorily purchased. So too those of several needy families, in a cul-de-sac just behind. Soon they would all vanish without trace. Big money had been talking again. A business syndicate from outside had swept in and told the town it needed a theatre holding 2,000 seats. The New Theatre they were going to call it.

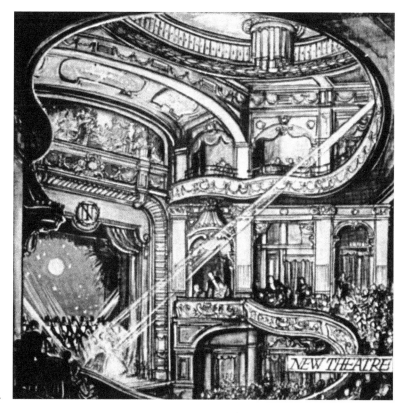

The New Theatre.

There was a sense of pride in Abington Street as the first shows began. Marie Lloyd came, as did one star after another, from Gracie Fields and George Formby to Clara Butt and Pavlova. In the interwar years musicals flourished and the New had its own orchestra. Malcolm Arnold's trumpet tutor, Frank Burton, was a regular in the pit (after finishing work at Tomkin's music shop in Palmerston Road). Malcolm was occasionally alongside him, and later played on stage as part of the London Philharmonic, when that orchestra came to town. In 1953 he returned with the LPO, this time conducting the premiere of his Coronation suite, *Homage to the Queen*. But the Coronation launched the rapid spread of small televisions. Soon the town was awash with them, bringing hard times. John Gielgud and Richard Burton performed one night at the New before barely two dozen. Strippers in saucy shows took over. In 1958, when the final curtain rang down, it was on *Strip, Strip, Hooray*.

There was a sense of outrage in Abington Street in 1960 as the demolition men moved in. The New was about to vanish without trace. A valedictory book was published, lovingly detailing its short life. Several of the Arnolds – Will, Malcolm and Ruth – joined its subscription list, and Ruth contributed the photo Max Miller gave her at the stage door. Great, indeed, was the sense of outrage in Abington Street. But, far away, somewhere up in the clouds, could that have been earnest Mr Broom and smart Miss Law treading the light fantastic in celestial celebration?

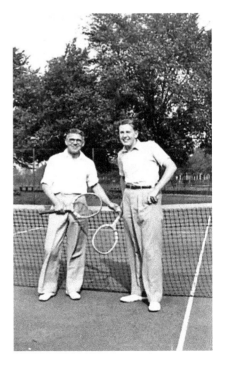

*Above Left:* A façade of distinction.

*Above Right:* New Theatre trumpeters Frank Burton and Malcolm Arnold.

# O

## 40. Overstone Observations

Overstone Road, like all such long, straight stretches of terraced housing, can sometimes look a little sombre. Once it had a boot-and-shoe factory at each end: the huge Hawkins concern at St Michael's Road and, up at Clare Street, the impressive triangular premises where, a hundred years ago, Joseph Dawson & Sons flourished. It also had some twenty lively little shops. Today they have virtually all gone. Walk down Overstone Road slowly, however, and you will begin to identify where they were, and sense, perhaps, a little of the atmosphere of the close-knit community that centred on these shops. Though not well-off and lacking modern amenities, the 1920s residents had compensations in the way they embraced the hardships and joys of daily life together.

Perhaps they felt some pride that their road took its name from a glamorous country house, Overstone Hall, on the outskirts of the town. Though created in the 1860s by the first Lord Overstone, he rarely used it, and it was only in the twentieth century that it came into its own as a somewhat grand girls' boarding school, one of whose most lively pupils was probably Malcolm Arnold's second wife, Isobel. In 1980 it was acquired by the New Testament Church of God, but the devastating fire damage of 2001 limited its attractions and a few years later, though still the owners, they moved their headquarters into the town. Little pride can currently be taken in Overstone Hall, which languishes in the top ten of the most endangered Victorian and Edwardian buildings in the country.

A grey day in Overstone Road.

# 41. Phipps of Phippsville

With a name almost as striking as his long, bushy beard, Pickering Phipps (1827–90) was another great pillar of the community in the golden age. An MP and twice-serving mayor, he was immensely rich, having inherited a thriving brewery founded in Bridge Street by his similarly named grandfather. He developed it into the largest in the Midlands. Phipps' ale, indeed, became synonymous with thirsty shoemakers, 'its hoppy flavour and bitterness cutting through the tannin-rich leather aroma' they spent their days inhaling.

As a public figure he was greatly influential in whetting the town's appetite for prestigious buildings. Privately, too, he was ambitious, commissioning Godwin's castle-like 'Rheinfelden' for the Billing Road and Edmund Law's Collingtree Grange as a country house standing in its own park to the west of the town. Alas, both these fine creations have not survived. But Pickering Phipps himself is far from forgotten. Soon after his death in 1890, his daughters donated a large piece of land for a church in his memory. St Matthew's resulted, funded by his son, the third Pickering Phipps. There is also a Pickering Phipps pub on the Wellingborough Road, and, though a merger in 1960 (after 159 years of independence) led to the Bridge Street brewery's demolition and the end of Phipps beers, quite recently the Phipps NBC brand name reappeared. In 2014, moreover, the restoration in Kingswell Street of the Albion Place Brewery (built in 1884 and once part of the Phipps empire) has meant that Phipps is again widely on sale, with Phipps IPA being brewed to an authentic 1930s recipe. The new Albion Brewery Bar, meanwhile, is really very special, its oak and glass partition allowing drinkers to admire the brewing process as they sample its results.

Finally, there is Phippsville – a whole area of the town (east of the Racecourse and south of the Kettering Road) that Pickering Phipps acquired and developed into a high-class suburb bearing his name. Perhaps Phippsville, then, is the ideal place to toast the great man with a glass of his real ale.

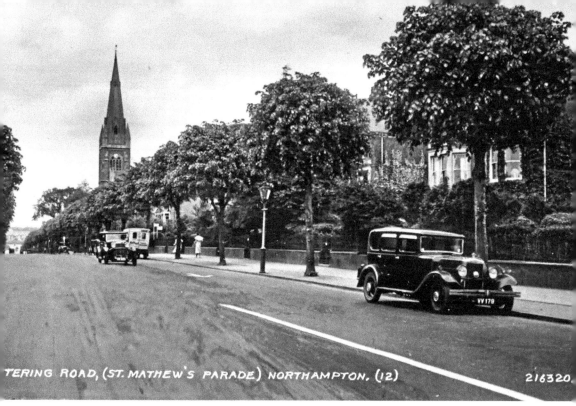

TERING ROAD, (ST. MATHEW'S PARADE) NORTHAMPTON. (12)     216320.

Phipps' Phippsville in the 1920s.

Phipps' Collingtree Grange (designed by E. F. Law).

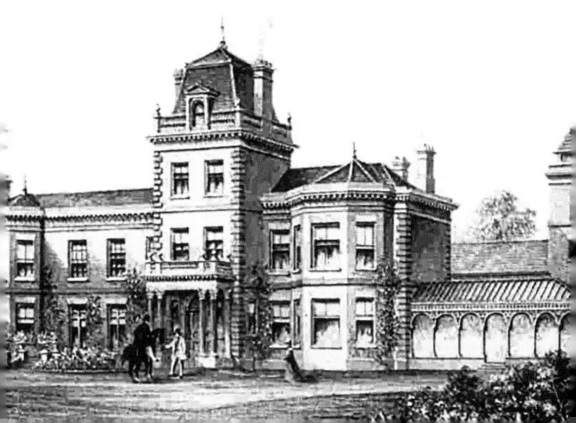

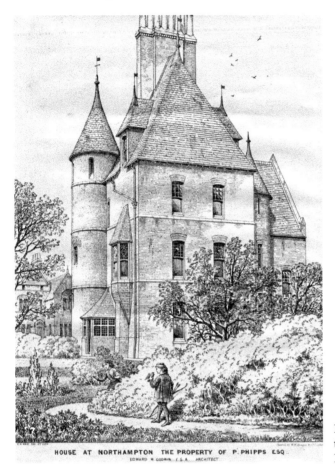

HOUSE AT NORTHAMPTON THE PROPERTY OF P. PHIPPS ESQ.
EDWARD W GODWIN F.S.A. ARCHITECT

Phipps' new Rheinfelden in the Billing Road (designed by E. W. Godwin).

# 42. Phipps of the Royal

When Mr Franklin in the early 1880s planned to add a theatre to his entertainment empire, he had only a small rectangular piece of land to offer. This land, moreover, was tucked away behind his hotel facing Swan Street, which in those days ran right up to Derngate (the road) over land now occupied by the Derngate Centre. Swan Street was not so much a road as an alley and hardly the place for the local gentry he envisaged in his more expensive seats. Franklin incorporated in his project, therefore, a tiny rectangular strip between his plot and the Guildhall Road. Although it was set at right angles to what would be the main body of the theatre and there could only be a narrow frontage on the Guildhall Road, this outlet might possibly enable an architect to create something viable. But few architects, he realised, would want to work in such a restricted and unpromising site.

This was probably the moment, therefore, when, like the good entrepreneur he was, he thought of his powerful friend Pickering Phipps, who was reputed to have

a relation – he wasn't sure of the exact details – who was London's leading theatre architect. Not only had Charles John Phipps built theatres all over England, but he had just created for Richard D'Oyly Carte's company a wonderful theatre in London called the Savoy, where the new comic operas of Gilbert and Sullivan were to be put on. If Pickering could somehow twist Charles Phipps' arm, the town might not only have a new, money-spinning theatre, but a highly prestigious one too. He'd call it an opera house to add further cachet. That was assuming, of course, that Pickering would swing things and that Charles Phipps' genius would somehow surmount all the difficulties of the small backyard plot.

Pickering was persuasive, and Charles Phipps duly arrived at Franklin's Hotel. The problems were indeed challenging, but his solutions masterful. The rectangular strip fronting Guildhall Road became, on the ground floor, the entrance foyer and box office, leading the gentry straight into the Circle. Excavations enabled the stalls (then known as 'the pit' and strictly for the lower classes) to be under ground level, approached from an entrance in Swan Street. The gallery, whose clients would be even rougher, was also entered from the dingy alley. Generous depth and height were compensations for the stage's necessarily narrow width. Backstage space was negligible, but a tunnel under Swan Street led to an extra three-storey building on the other side, for dressing rooms underneath workshops. That great stars like Henry Irving and Ellen Terry would one day have to use the tunnel was apparently not Charles Phipps' concern.

The theatre opened in 1883 and, only a year later, achieved a real coup. Gilbert and Sullivan's *The Mikado*, the new smash-hit, was to go on tour after completing its first London season at the Savoy. Charles Phipps would have fancied the idea of it giving his latest provincial theatre a big boost. 'Take it first to my new Opera House in Northampton', he must have told D'Oyly Carte, 'You'll not only get cut price hotel accommodation at Franklin's, but the best real ale in the country.'

# 43. Piano Playing Annie

Will Arnold's wife, Annie Hawes (1883–1955), was a well-known phenomenon in the early twentieth century, the self-effacing woman who held the whole family together and, though denied her own career by the conventions of the day, took great pleasure in doing her utmost to foster and support the ambitions of her menfolk. In a later era Annie would possibly have forged a career as a professional concert pianist. Her son Malcolm, familiar with many of the world's greatest virtuosi, always maintained she was a top-notch player. She came from a highly musical family. Her father ran music shops and taught a wide range of instruments. Her great-grandfather had been a nationally famous composer and singer in Regency times and her great-aunt Maria, a superb contralto, was the toast of London.

As a young girl Annie was soon participating in tableaux vivants and concerts for charities at prestigious venues like the Guildhall. It was not long, too, before she

joincd her parents and talented elder sisters in a musical sextet, a Northampton version of the von Trapps. It was while she was organist of the Kingsley Park Methodist Church that she first met Will, who often preached there and was himself an organist for the Horsemarket Methodists. They were married at Kingsley Park in 1907 and, at twenty-four, Annie settled down to the all-consuming business of being Mrs Arnold, wife of a shoe baron's son and a would-be shoe baron himself. She continued, of course, to play the piano and, as Malcolm's accompanist, took to the Northampton concert platforms again as he displayed his trumpet virtuosity. Like all her children, Malcolm benefited enormously from her sophisticated input, especially when, instead of school, he depended on tutoring. By the time he went to college he had a breadth of knowledge, both musical and general, that no formal education could have bettered.

Young Malcolm would always write his mother a short piano piece on her birthdays, several such manuscripts coming to light not so many years ago. Published and recorded, they are being played more and more – some compensation, perhaps, for the fine pianist who could never have a career herself.

Young Annie Hawes.

# 44. Quiet Queen Eleanor

There is a well-known Gothic cross high on a hill overlooking the town where the London Road meets the southern by-pass. It is one of three survivors from the series erected in 1290 by Edward I to mark the overnight stops of the cortège taking the embalmed body of his wife, Queen Eleanor, from Nottinghamshire to London. A play (*Mephistopheles and the Golden Apples*) by Ernest Reynolds brings the difficulties of this operation to vivid life. The speaker is a squire accompanying the king's party, after it had stopped for the night at Delapre Abbey:

<div align="center">

The Queen stuck deep in the mud at Geddington;
It was only with some cursing and swearing, which it was lucky
the King never heard,
That we got the cart out on the go again.
Then, just outside Northampton, there was a fog,
And we missed the road and went floundering in the floods,
With the Queen's cart up to the hubs in slush and mud.
The King looked white, though the torch shone red in the fog,
White that we might come to a river and lose the Queen.
Then we lifted our torches and all stood round in a ring
(With the water up to our knees and the Queen's cart wheels)
And a monk we had with us sang a hymn he had learned in Spain
In Eleanor's own Castile.
We moved again
And presently came to Northampton lights, to the gate,
But the King never spoke when we saw lamps twink in the fog
And shouted as loud as we dared (with the Queen at our backs),
When the Mayor came out to meet us, with lights, in his gown and his chain...

</div>

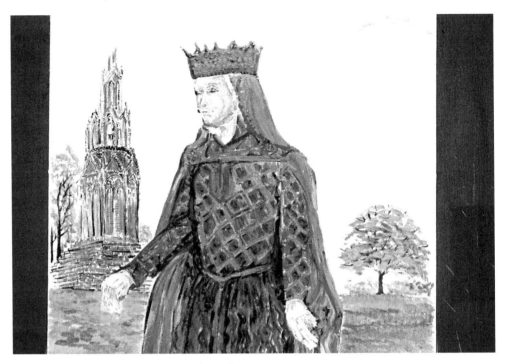

Queen Eleanor, as imagined during the Delapre renovations.

Queen Eleanor, as depicted on Matthew Holding's Guildhall extension.

# R

## 45. Robinson of the Rep

Tom Osborne Robinson (1904–76) was a brilliant artist. Trained at the local school of art, he had been inspired by Bakst's designs when on a visit to London to see Diaghilev's *The Sleeping Beauty*. A master of many styles, modern as well as traditional, he was at his most characteristic when being Bakstian, luxuriating in 'a buoyant, grandiose organisation of space, expert orchestration of colours and inexhaustible wealth of invention'. For most of his working life, from 1928 until his death nearly fifty years later, he was also the highly distinguished scenic designer of the Royal Theatre. He had the talent to be working in London – on a brief foray at the Old Vic (where he designed Laurence Olivier's *Hamlet*) he was offered a permanent job as scenic designer by Lilian Baylis – but he opted instead for his home town and beloved Royal Theatre. It was known at the time as the 'Rep' – home to a small professional repertory company that, by working phenomenally hard, put on a new play each week. Over the years, actors and directors came and went, but Robinson remained, the hub of the place. Without him there would have been no 'Rep', and the Royal almost certainly would have folded.

He applied his talents and energies not just to the stage but the whole theatre. Nigel Hawthorne, who worked as a young man at the Rep, loved his idiosyncrasies: 'Each year on 23 April, Shakespeare's birthday, we would gather round the bard's bust at the back of the stalls and toast him in cheap, sweet sherry. This little ceremony was a small indication of the tradition Tom Robinson had built up. He loved every brick, every cornice, every strip of wallpaper – every inch of that theatre.' He masterminded and led its interior redecoration as a matter of course. It positively glowed in its crimsons and golds. Robinson's murals, too, delighted the eye. When the otherwise glorious makeover of 2005–06 came along, there was a fear that the 'pursuit of some spurious historical authenticity' (as Richard Foulkes warned at the time) could easily eradicate 'the organic heritage built up over 120 years' and 'in particular the contributions of two remarkable Northampton-born men – Osborne Robinson for his murals and Henry Bird for his stunning drop-curtain'. Though most of Robinson's work was indeed lost, the Harlequin mural in the circle corridor happily survives. Bird's drop-curtain, too.

1927
1957

NORTHAMPTO
REPERTORY THEAT

PROGRAMME PRICE FOURPENCE

*Left*: Tom Osborne Robinson.

*Right*: Celebration of fifty years of a repertory company at the Royal.

Robinson was always immensely busy. He gave stimulating evening classes at the Northampton Art School and also lectured in American universities. He was on the Arts Council Drama Panel and in 1969 was awarded the OBE for his services to the theatre. He was a huge and generous supporter of the Museum and Art Gallery, the latter being renamed in 1977 'the Osborne Robinson Gallery' in his memory. His extensive poster collection, generously bequeathed, is now with the university's art department.

Robinson's last great work was a series of murals telling the history of the town. Although he had been one of the fiercest critics of the pulling down of the Emporium Arcade and other historic buildings for the creation of the Grosvenor Centre, he accepted the Centre's commission for what were to be huge and masterfully flamboyant compositions, painted on heavy wooden panels, which were on public display in the Centre until 1999. (A twelfth, apparently, was quietly rejected as it included a modern protester with a 'Save the Emporium Arcade' banner.) It is disappointing that a new home has yet to be found for them. They are currently locked safely away in the university's art department.

A gentle man, for all his flamboyance, Tom Robinson lived in the Derngate, just a few doors away from the Charles Rennie Mackintosh house, whose cause he strongly championed. 'I see him now,' recalled Nigel Hawthorne affectionately, 'striding round the town like some nobleman of the Italian Renaissance, big-bellied, big-nosed and

bearded, glancing up at his favourite pieces of architecture as though he had fashioned them all himself and would guard them with his life.'

# 46. Rubbra and Alwyn

Rubbra and Alwyn, though sounding a little like another couple of shoe barons, were in fact Northampton-born composers who made it to the big-time despite fairly modest beginnings. When Edmund Rubbra (1901–86) was born, his father was working in Miller's in Arthur Street, making wooden lasts. One of his uncles was a 'foreman shoemaker' and another owned a small factory. A third, however, ran a piano and music shop at No. 6 Cowper Street (Gibson's), and it was on a loaned piano from there that Edmund was soon prospering, becoming at ten the pianist of the Primrose Hill Congregational Church (another Alex Anderson creation). In 1912 the family moved from No. 2 Balfour Road to a shop at No. 52 Overstone Road, where his father ran a watch and music-box repair business. After leaving the Kettering Road School at fourteen, Edmund declined involvement in his uncle's factory, preferring work at Crockett & Jones and then as a railway station clerk, which allowed him time for music lessons with the organists of St Matthew's and All Saints'. He made his mark locally by organising and playing in First World War charity concerts at the library's Carnegie Hall, and a scholarship to Reading University followed, with lessons from Gustav Holst. He was on his way...

William Alwyn (1905–85), whose real name was William Alwyn Smith, was born over the grocery shop (long since demolished) that his parents ran at No. 52 Kettering Road, facing St Michael's Road. His father, who had scholarly ambitions, called it Shakspere Stores, adopting the spelling Shakespeare himself had favoured. Inspired by bands in Abington Park, William was soon learning the piccolo and flute and never missed a musical event at the New Theatre. He also haunted Wantage Road. 'Northants got badly beaten by Lancashire,' wrote young William in his diary. 'I think I shall emigrate if this goes on.' After the Kettering Road and the Town and County schools, at fourteen he began full-time work in the store, but lessons from Methodist friends of Will Arnold, the Stricklands, helped him win a scholarship to the Royal Academy of Music. He felt terrible when he heard the news: 'I was to inherit the shop – the shop my father had built from a nondescript small trade into a flourishing personal business! I was to provide the people with tea and sugar, butter and bacon, Christmas hams and tinned tomatoes!' He was reassured, however, by his father's delight. A new world was soon opening...

Both composers' heyday was in the '40s and '50s. Today their music has a comparatively small following. The enthusiastic words of Rubbra's biographer Leo Black, however, could equally apply to both of them:

> The crucial thing is the music's sheer quality, its ideas, the personality it communicates, the world of search and discovery that opens up to us when we hear it. His journey from his first symphony to his last was one such as many

of us make in the course of a lifetime; its uniqueness comes from the fact that at every stage it announces itself through unforgettably inventive and attractive music. That is something to survive all fluctuations of taste: may its time come again, and soon.

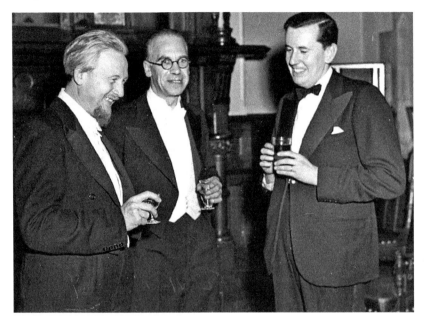

Edmund Rubbra, William Alwyn and Malcolm Arnold.

Nos 52, 54 & 56 Overstone Road. The Rubbras' shop (No. 52) once had a façade similar to No. 56's.

# S

## 47. Showpiece Seventy-Eight

No. 78 Derngate is a Regency terraced house with an interior designed by the highly esteemed Glaswegian Charles Rennie Mackintosh (1868–1928). It has been wonderfully refurbished and most imaginatively set out for visitors, thanks to the acquisition of adjacent property. The Mackintosh décor dates to 1916 when the house had a new owner, Wenman Bassett-Lowke, the creator of the beguiling Bassett-Lowke model railways and a modernist full of avant-garde ambitions. He was marrying Jane Jones (daughter of the co-founder of Crockett & Jones) and clearly wanted his bride to have a home that would be the talk of the town.

One of his collaborators, responsible for several structural improvements to No. 78, was the admirable architect Alex Anderson, a good friend of Bassett-Lowke's, who lived at No. 72. Anderson had designed a Bassett-Lowke warehouse in Kingswell Street and was among the major shareholders of his Miniature Railways of Great Britain project. With his strong connections with the Glasgow School of Art, Anderson would have been instrumental in acquiring Mackintosh for Northampton.

The décor is stunningly modernist and before its time – 'dense, rich and striking' in the words of architect and designer Edwin Heathcote. And each room has its own very different scheme: 'From the front door with its stepped pediment, decorative lantern and stained glass,' noted Heathcote, 'to the stripy black, blue and white bedroom, it is one of the most distinctive domestic interiors in Britain.' He was particularly taken by the way it looks forward to art deco: 'The black walls with appliqué gold geometric patterns, the stepped Aztec motifs on doors and fireplace, the vertical stripes and the blocky geometric forms of the furniture all predict the kind of Hollywood glamour that is difficult to reconcile with a Northampton terrace.'

It's a showpiece that can shock as well as delight. One reporter at the 2006 reopening, though marvelling that the front door's light-fitting was worth £20,000 and the glass-walled staircase insured for £500,000, found some of the rooms quite overpowering: 'The hall-cum-lounge with its matte black walls, startlingly groovy swirly-patterned curtains, stepped and niched matte black fireplace and stencilled yellow, green and red triangles (apparently an abstract forest) looks to me like a cross between a Satanist chapel and an eye test.' The guest bedroom was similarly upsetting: 'It socks

you between the eyes with a violent canopy of black and white stripes, painted on the wall and ceiling above the bed. Nobody could survive in there with a hangover.' Years earlier George Bernard Shaw, a friend of the family, had been similarly ironic. When asked if he had slept well at No. 78, he replied, 'Yes, thank you. I always sleep with my eyes shut.'

The Bassett-Lowkes spent nine years at No. 78 before the restless Wenman commissioned the German modernist Peter Behrens to create 'New Ways' in the Wellingborough Road, backing onto Abington Park. It duly caused another sensation.

# 48. Solitary St Michael

St Michael's Church is not usually a solitary place. Today it enjoys a strong Romanian presence and it has served a very large parish since taking on the parishioners from doomed St Edmund's in the late '70s. Indeed, from its earliest days it has never been a solitary place. Built in red brick in 1882 as an integral part of a new shoemaking estate, it busily shared the highs and lows of the district's life throughout the golden age, a district that was to be studded with big factories like Crockett & Jones, J. Sears and Arnold Brothers.

St Michael's, however, was an unusually solitary place on one particular Monday morning in 1885. It was Billy Arnold's wedding day and, strangely, solitude was what he wanted. As he later explained, 'Being self-conscious, I did not want many in the church'. Perhaps this was because of poverty. It was still some years before he began running his own small business and he was currently lodging with an uncle in Hunter Street. He had proposed to the daughter of a shoe-worker who lived opposite. Deeply

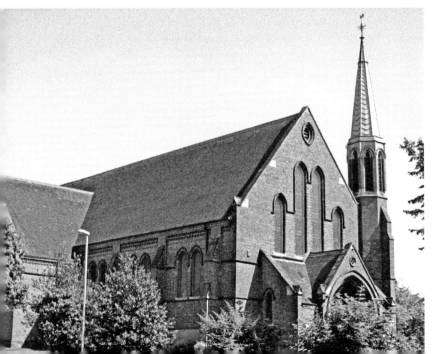

St Michael's
Church.

religious, she had told Billy that she would only marry him if he signed the pledge for ever. There was to be no more boozing down at the Cricketers' Arms in Hervey Street. Perhaps, then, the self-consciousness came from a fear that his friends might mock his new lifestyle.

Taking no chances, Billy had asked the minister for the wedding to be performed an hour earlier than advertised. Things worked out perfectly: 'It was a wet morning, and, besides the vicar and the verger, there was only one other person present, the old landlady where I used to lodge. We had no cab, we felt we could not afford it.' So they walked back in the rain together to the bride's parents' house in Hunter Street, where they were to live for the next year and where their first child, Will, would be born.

St Michael's can rarely have seen such a solitary wedding.

# 49. Stylish St George

St George's Avenue has a stylish setting, running the length of the north side of the Racecourse. As the twentieth century dawned and the new Edwardian era promised secure continuation of the shoemaking golden age, a particularly elegant terrace was created at the Kingsley Road end – tall houses faced with ornamented stone, looking out onto wide green expanses, and, to the rear, stretching far back into their high-walled gardens. The avenue's ambience was shortly to become all the more stylish when, in 1903, the Racecourse was deemed too dangerous and all the razzmatazz of the meetings came to an end.

Thirty years on, in 1934, Will Arnold and his family moved into Craigmore at No. 106. Though it lacked the distinction of Cliftonville's Fairview and suggested that the economic problems of the '30s were adversely affecting Arnold Brothers, it still had much to offer. With its three floors and basement, there was plenty of room for the family of seven and their ever-faithful servant, Lizzie Witts. The youngest of the children, thirteen-year-old Malcolm, found it much to his liking and soon commandeered the basement for his jazz group, which he led on trumpet or a swinging violin. With Phil on clarinet and alto sax, Ruth on piano and Cliff on guitar, they could usually make themselves audible in the sitting room above. Malcolm's trumpet playing had gone into a highly flamboyant direction since Easter, when, down on holiday in Bournemouth, he had heard and met the great Louis Armstrong. 'He came up and signed my programme, writing "Satchmo". I looked at him in wonder. "Isn't your name Louis Armstrong?" I asked. "Ah'm Satchmo, kid," he replied.'

On good days they might even have been heard two doors away at Normanhurst, where the avenue acquired further style from William Wren, who over forty years earlier had founded the first of the Northampton factories producing Wren's Boot Polish. At the time the Arnolds moved in, William Wren had just introduced a product that was the talk of St George's Avenue, a furniture cream called Lavendo that stylishly perfumed as it polished.

Craigmore, St George's Avenue.

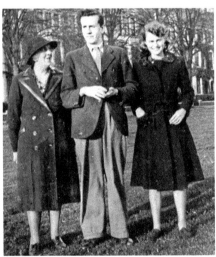

Malcolm Arnold, his mother and wife Sheila on the Racecourse, early 1940s.

Not far down the road but beyond the terrace, there was a building of considerable style: the College of Technology with a School of Art attached, where Henry Bird was to teach for over twenty years. In the fullness of time, in the 1970s, the Tech would become the Nene College of Education, which, in turn, would enjoy further metamorphosis in 2005. St George's Avenue has now taken on a new kind of style as the proud home of Northampton University's Avenue Campus.

Will Arnold outside
Craigmore, 1950s.

# 50. Surprising St John

Curving like a moat around a castle, the inner ring road's one-way diversion at the bottom of Bridge Street has created a small pedestrian island. One of the town's most intriguing medieval remains is to be found there, the so-called Hospital of St John. Drivers can easily sweep past without noticing it. But it is very much worth exploring.

The buildings were once part of a twelfth-century hospital or hospice dedicated to St John the Baptist and St John the Evangelist, created and run by monks for the needs of pilgrims, a place of rest and recreation, and much used, too, by the poor, the sick and the unwanted. In addition to an infirmary, the hospice had a tiny chapel and a large administrative complex that became known as 'the master's house'. The hospice served its worthy purpose until the 1500s, when, at the time of the Reformation, the site was seized by Henry VIII. He let it fall into ruin, and centuries of neglect followed. The Midland Railway acquired the hospital in the 1870s and knocked down the master's house to make way for the town's first railway station, St John's, but the chapel and infirmary were sold, first to a storage firm and then to the Catholic Church. St John's Station, which had offered a useful link to Bedford, was closed and demolished in 1939, but after the war the chapel served again as a Catholic Church until a fire led to its closure in 1990.

The sorry historic buildings were eventually acquired in 2004 by an imaginative business group and converted, after painstaking restoration, into a modern restaurant. But could such a conversion be tastefully done? The high-roofed infirmary-cum-restaurant, complete with one or two religious vignettes in stained glass, is splendidly atmospheric. And though it is something of a surprise to be

sipping a drink in the little chapel-cum-bar before a stained-glass image of Jesus on the cross, the general atmosphere is respectful and attractive. It's a remarkable conversion. Somehow, the whole thing works. Indeed, 'The Church Restaurant' is modern Northampton at its very best.

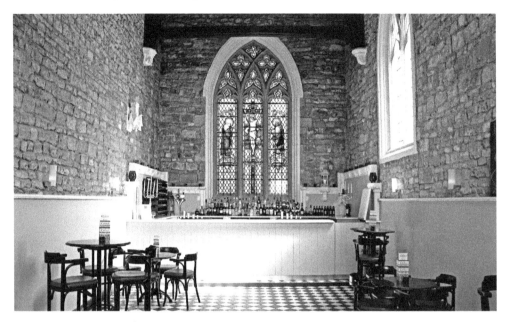

The Church Restaurant's bar.

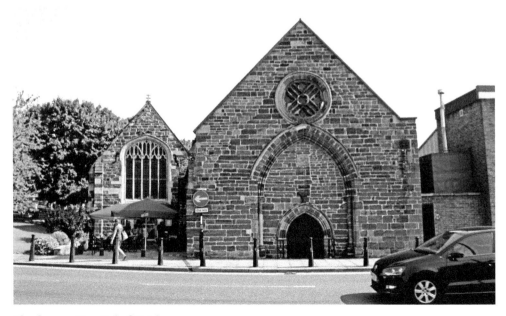

The former Hospital of St John.

# T

## 51. Tull from Tottenham

Walter Tull (1888–1918) was the son of a West Indian immigrant, a carpenter who married an English girl in Folkestone. Brought up in a strongly Methodist Bethnal Green orphanage after the death of both parents, he developed into a talented footballer, winning the FA Amateur Cup as a centre-forward with Clapton. After an auspicious professional debut for Tottenham Hotspur against Manchester United in the First Division, as an inside forward, he played nine more games for Spurs over two seasons (1910–12). His White Hart Lane career is something of a mystery. Short and stocky with a powerful shot and neat footwork, he clearly was a talented player yet never commanded a regular place. Though sporting prowess won him acceptance among his peers, as a black man in a white man's world he was the target of considerable crowd abuse in some matches, and this could well have influenced team selection. His move to Northampton and the more relaxed Southern League proved beneficial. At Wantage Road he overcame prejudice and proved very popular, playing well over 100 games for Northampton before the First World War broke out.

He at once volunteered to join a Footballers' Battalion of the Middlesex Regiment. It was an impressive decision, as biographer Phil Vasili suggests:

> He was enjoying life as a professional footballer – a working-class man playing for a working-class club in a working-class town looked up to by working-class people. He brought kudos and recognition to those around him. He had that most precious and elusive commodity for a Black Briton: respect from the community in which he lived. Compared to the daily toil of the shoe worker in one of Northampton's numerous footwear factories he had the life of Reilly.

Yet he gave it all up.

He was fighting in France by November 1915 and had reached the rank of sergeant when at the Ancre in the first Battle of the Somme. In early 1917 there was a further, remarkable promotion that says much about his personal qualities and upbringing. He became the first commissioned officer of mixed heritage in a regular British Army regiment, defeating the official sanction against those who were not 'of pure

European descent'. As Second Lieutenant Tull he fought at the Battle of Messines and the Third Battle of Ypres (Menin Road Ridge), before transfer for four months to the Italian Front, where, it seems, he was recommended for the MC for leading a successful night raid into enemy lines, only for the honour to be denied him by pig-headed officialdom. Tull returned to northern France in March 1918 in time to face the Germans' Spring Offensive. Having fought in the Second Battle of the Somme (St Quentin), he was finally killed, after two and a half years of active service, near the village of Favreuil in the Pas-de-Calais at the Battle of Bapaume. His body was never recovered.

Nearly a hundred years on, this young hero, who took on and overcame all the denigration and ridicule that came his way through racial prejudice, is being justly celebrated. He has recently had a road, a pub and an office block named after him. There is also a striking memorial outside Sixfields Stadium.

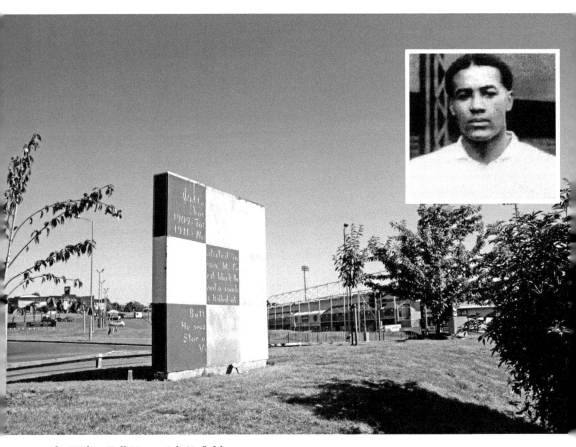

The Walter Tull Memorial, Sixfields.

## 52. Unsettled St Peter

The magnificent Norman Church of St Peter has been a source of inspiration for generation after generation for nearly 900 years. Henry Bird, for example, a former chorister of St Peter's, declared that it was the beauty of its capitals and the skill with which they were carved that had fired him with the determination to succeed as an artist. For such a historic church no longer to have a parish of its own must be a cause of some misgiving in ecclesiastical circles. But having become redundant in the 1990s, St Peter's would seem to have a somewhat unsettled future. Occasional lectures and services are held. It is open to visitors on certain days. And as a Grade I-listed building in the care of The Churches Conservation Trust, its physical condition is in expert hands. Costly restoration work has already been undertaken, emphasising, among other things, the contributions of Victorians like Sir George Gilbert Scott and his family. It could possibly find new vitality within the heritage scheme that the Friends of the Castle put forward. St Peter's and the royal castle were, of course, once very closely connected. Their proximity accounts for the remarkably rich Norman carving that once inspired Henry Bird. The great western arch beneath the tower was described by Nikolaus Pevsner 'as a tour de force of Norman inventiveness'...

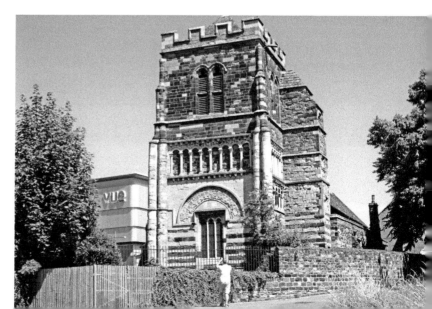

St Peter's with
modernity close by.

# 53. Vivat Victoria

Dating to the 1870s, Victoria Road could possibly have been named after the reigning monarch, but the close proximity of Harold, Cyril, Ethel and Edith Streets suggests that Victoria was probably just another of the developer's children. Straight as a die and modest as a church mouse, it is one of those streets with rather more to offer the casual visitor than would at first seem likely. At one end, where the Wellingborough Road meets Abington Square, all is workaday bustle; at the other, there's the General Hospital across the Billing Road. Casual visitors will be few and far between, and that's a pity, for it has much to say about the boot-and-shoe era: a tight little complex of homes and small factories, complete with pub (the Crown & Anchor) and Congregational Church (designed with modest spires and turrets by Matthew Holding). The terraced houses, as so often elsewhere, have elaborate doorways, their curving flower-filled friezes supported by pilasters whose capitals contain considerable classical embellishment. Six former boot-and-shoe factories are distinguishable.

In the 1920s Will Arnold and his family would have been living just around the corner, at Cliftonville, off the Billing Road. He would surely have known Tom Richardson and John Berrill, sharing the most impressive factory in the road at Nos 42–44, with its date of 1873 clearly displayed in its central pediment. George Frecknall's premises at No. 39 would have been familiar; so, too, Will Garratt's at Nos 32–34. At Nos 10–12, the factory run by Will Todd has been sympathetically converted to residential use, the loading doors on the upper two floors carefully respected. At the three-storey No. 2, James Walding's factory likewise still has the bracket of its pulley system. No. 2b might look like an old factory but was, in fact, the Union Children's Home, facing Will Toms' superb footwear company at Nos 3–7.

This unassuming road would have had a sense of permanence in Will Arnold's day, but, of course, the factory owners came and went. Though no longer involved in boots and shoes, the little factories remain, testimony to much ambition and endeavour.

A factory, attractively converted to apartments, beside Victoria Road's pub.

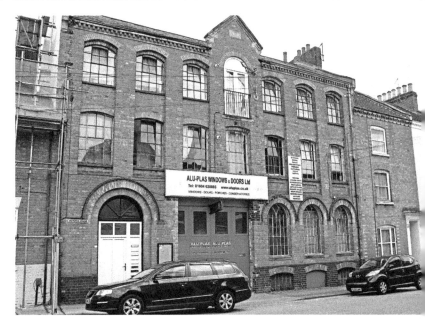

Richardson and Berrill's former factory, Nos 42–44 Victoria Road.

Victorian classicism, Victoria Road.

Holding's
Congregational
Church, looking down
Thenford Street.

# 54. Volatility Venerated

The town has always had a strong spirit of dissent. It is no surprise, then, that it has enthusiastically honoured Charles Bradlaugh (1833–91), a volatile politician who championed a number of what were, in late Victorian times, minority causes: atheism, republicanism, trade unionism and women's suffrage. Founder of the National Secular Society, he caused such a sensation when MP for Northampton by refusing to take the Oath of Allegiance to the Crown that the Oath Act was eventually changed. 3,000 attended his funeral and a life-size statue in terracotta (by George Tinworth) was soon erected in prominent position at the junction of the Wellingborough and Kettering Roads. Today the university has a Bradlaugh Hall. There is a Charles Bradlaugh pub and a Charles Bradlaugh Society that specially remembers him each birthday. London, too, has honoured him. In November 2016 a bust of Bradlaugh was presented by the National Secular Society to the Palace of Westminster.

Charles
Bradlaugh in
terracotta.

# W

## 55. Wantage Road Write-up

Wantage Road, named in honour of Lady Wantage who donated nearby Abington Park, is known throughout the sporting world as a special cricket venue, the home of Northamptonshire for well over a hundred years. It was the home, too, of Northampton Town FC until the move to Sixfields in 1994 and will always be remembered as the ground where George Best scored six goals for Manchester United one February afternoon in 1970. The cricket ground has been wonderfully well developed in recent years. What with the floodlights, new grandstands and the modern big-hitting competitions, it offers entertainment on a completely new level from a few years ago. It is a real feather in the town's sporting cap.

The road is less well known as the home of Dr Ernest Reynolds (1910–86). A writer on a wide range of topics, he was a university lecturer, poet and playwright, one of his BBC radio plays (*Candlemas Night*) coming complete with a score by Malcolm

The 'toothpick' spire of the Park Street Methodist Church seen from the county cricket ground.

Arnold. He lived for many years at No. 43, devoted to the best interests of the town and its cultural heritage. In his later years he rarely strayed from his home, 'an Aladdin's cave', and, sadly just weeks after his death, thieves ransacked it, making off with a priceless haul of china figures, clocks and other valuables. They may well have been alerted to the treasure trove by one of his books, *The Plain Man's Guide to Antique Collecting*.

# 56. Well-connected Walter

Father Walter Hussey (1909–85), 'the last great patron of art in the Church of England', began his single-minded crusade of commissioning works from leading artists, musicians and writers during his eighteen years as vicar of St Matthew's (1937–55). In doing so he cultivated many friendships, most notably, perhaps, with Benjamin Britten whose memorial address he gave in Westminster Abbey. In addition to Britten, notable contributors to Hussey's St Matthew's included Graham Sutherland, John Piper, W. H. Auden, Norman Nicholson, Michael Tippett, Lennox Berkeley, Gerald Finzi, Kirsten Flagstad and, of course, Edmund Rubbra and Malcolm Arnold.

Of all Father Hussey's great coups the most remarkable has to be the avant-garde sculpture of the *Madonna and Child* by Henry Moore, a work of major importance, unveiled in the north transept in February 1944. Hussey and Moore were in close touch throughout the six-month project. 'The Madonna and Child should have an austerity and a nobility and some touch of grandeur,' Moore told Hussey early on. 'From the sketches and little models I've done, the one we've chosen has, I think, a quiet dignity and gentleness.' The Madonna's head was to be turned towards people walking up the central aisle; the Child's to engage from head-on. Visiting Moore on one occasion in the early stages of the work, Hussey somehow persuaded the great sculptor to let him experiment on the block of brown stone: 'Taking his claw chisel and round mallet, I struck off some pieces (which I still have!) without causing any serious damage.'

*The Madonna and Child* finally arrived in January 1944: 'It was a cold day,' wrote Hussey, 'with a biting wind, and it took a good deal of effort to get the sculpture into the church and in position, where it was covered over with a large cloth. The next morning Moore adjusted the lighting and made finishing touches to the statue – I remember him pencilling-in some details to the Madonna's finger-nails'. The unveiling service on 19 February had a fraught beginning. The Moores were coming up by train from London with the Sutherlands and other VIPs, but there had been much enemy bombing the night before and the line had been much affected. On a freezing day, the VIPs shivered in an unheated carriage awaiting lengthy rail repairs, while an anxious buffet lunch took place in the church. By the service's scheduled 2.30 start they had still not arrived, nor had Louis MacNeice (Hussey's contemporary at Marlborough College) and Benjamin Britten (who was to conduct his St Matthew's

cantata). Hussey's invitation to William Walton to conduct in his stead did not go down well: 'His relations with Britten were rather strained at the time.' Another hour went by. The congregation sat in solemn silence, getting steadily colder. A bishop with an aversion to the avant-garde sulked explosively in the vestry. When, just before teatime, Moore and the VIPs eventually arrived, 'very cold and starving', they gallantly strode straight to their places. Hussey's awful nightmare was over.

The church's tradition of arts patronage has been maintained. In 1992, for example, Malcolm Pollard's *Risen Christ* was commissioned in Walter Hussey's memory. The wafer-thin Christ in Byzantine style with a strangely narrow body, strikingly suspended before a wrought-iron cross, is an appropriately challenging tribute.

# 57. We Shall Remember Them

Nearly 3,000 men from Northampton perished in the First World War. They were commemorated in 1926 with a Lutyens memorial on Wood Hill, and again, in 1936, with a Garden of Remembrance, including a colonnade with the names of the fallen, at the junction of the Wellingborough and Kettering Roads. At the same time, a memorial to the magnificent Edgar Mobbs, which had been previously sited at the southern end of the Market Square, became the new garden's focal point.

Two specific families we have met feature among the multitude of names. James Crockett, whose father co-founded Crockett & Jones, was already being trained in the business when war intervened. He was killed on the Somme in 1916 at the age of twenty-two. As an intelligence officer tasked with locating enemy snipers, he had gone out time and time again on dangerous missions to obtain information, which was said to have 'always possessed the priceless quality of being reliable'.

Ralph Paton Taylor's death at twenty motivated the building of the Castilian Street Memorial Hall. Brought up (at Abington Lodge) and educated locally, he had been rejected by the army on fitness grounds in 1914. Having doggedly managed to get this decision reversed, he was commissioned into the Northamptonshire Regiment and sent out to France in 1916 (with the 10th South Wales Borderers) just in time for the start of the horrors on the Somme. He lasted nine days. 'With great bravery,' his parents were subsequently told, 'your son led his platoon into action and unfortunately he was hit. He was carried out of action and buried on the field of battle.' He had gone over the top in the early afternoon as yet another attack was made on Mametz Wood, which involved stumbling over the dead and dying of the previous assault. He was subsequently reburied in Dantzig Alley British Cemetery. His sword, proudly engraved with his name, was donated to the Imperial War Museum.

After the Second World War, a further 700 names were added to the Garden of Remembrance. Among them is Philip Arnold, Malcolm's closest brother. Earmarked for a lifetime with Arnold Brothers, Phil had already spent six months in Nazi Germany studying new methods of boot manufacture. Convinced that conflict was

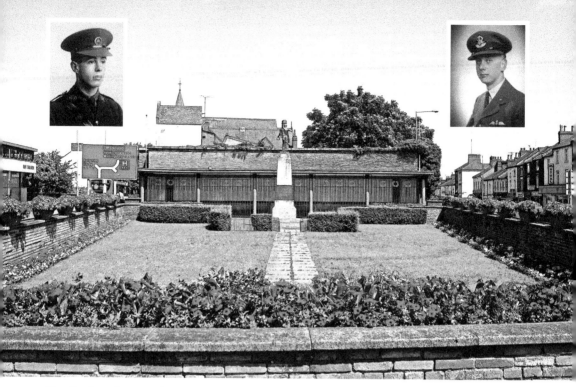

The Garden of Remembrance. *Inset*: Ralph Taylor and Philip Arnold.

inevitable, he had joined the RAF Voluntary Reserve in 1937, so was a fully qualified pilot by the outbreak of war. He seemed to lead a charmed life: 'I was on the first bombing raid on Berlin on Saturday night,' he told his parents cheerfully. 'I've got one of the safety pins of one of the bombs we dropped there that I'll give you when I see you next.' He survived by skill and luck for nearly a year, until, in November 1940, he failed to return from yet another lengthy mission over enemy territory. The family had to wait for eight months for confirmation of his death. He was twenty-one.

# 58. Who Was Whyte-Melville?

Above a side entrance to the Fox & Quill in Fish Street, an attractively carved inscription tells us that we are outside what was once the Whyte-Melville Hall, part of a Working Men's Club & Institute. So who was Whyte-Melville? The answer lies on the town's northern outskirts in the village of Boughton, where, beside a little church, there's an outstanding pub called The Whyte Melville. It was once the country home of Northampton's great Victorian novelist George Whyte-Melville (1821–78), a man whose successful life was dominated by two passions: hunting and writing – the fox and quill.

Most helpfully, the pub has a bookshelf full of his novels as well as a framed picture of their whiskery author. Son of a Scottish laird – he would spend the summers golfing in Scotland and there is a memorial to him in St Andrews – he was educated

Whyte-Melville's former working men's club.

at Eton, spent ten years as an army officer, and then, in 1849, settled down with his wife and daughter at Boughton, not far from the kennels of the Pytchley Hunt, whose long-serving honourable secretary he became. His first novel, *Digby Grant*, was a huge success (1853), paving the way for further popular romances like *Kate Coventry*, *Holmby House*, *Market Harborough* and *The Gladiators*. *Holmby House* has much local colour. ('A light cloud of smoke floats above the spot where lies fair Northampton town.') He had a devoted readership, particularly among the upper classes, and though his hunting scenes would not be to every modern reader's taste, the novels still read easily. Not needing the money he made from his writing, he scrupulously donated it to good causes. The education of the underprivileged was one of his particular concerns – hence the Working Men's Club on St Giles Street, with the capacious Whyte-Melville Hall (now a bar) entered from Fish Street, an elegant building that arose from the proceeds of a single bestseller.

In 1863 he moved to grander accommodation at Wootton Hall on the other side of the town, before settling three years later in London to enable his daughter to 'come out' in society. That accomplished, he headed back to the country, this time opting for Gloucestershire where he continued to write popular successes. He wrote poetry, too, the melancholy 'Goodbye' becoming a great hit, set to music by Tosti and sung by Nellie Melba. His death, in a hunting accident at the age of fifty-seven, shocked the nation. He was fondly remembered as 'kindly, modest, gifted with a sense of humour and a wit sometimes tart'. His fame endured another fifty years,

and even today, each issue of the magazine *Horse and Hound* begins with a famous Whyte-Melville quotation: 'I freely admit that the best of my fun, I owe it to horse and hound.'

Whyte-Melville's former country home, Boughton.

Novelist and philanthropist George Whyte-Melville.

# 59. Xenophobia Confronted

Xenophobia, which comes in many dangerous forms, finds a strong and helpful riposte in the recent Walter Tull Memorial, situated outside the Sixfields Football Stadium. Walter Tull's life, we are reminded, was one that 'ridiculed the barriers of ignorance that tried to deny people of colour equality with their contemporaries' and 'stands testament to a determination to confront those people and those obstacles that sought to diminish him and the world in which he lived'. There is thought-provoking symbolism for us, too, in the memorial's squares of black, white and grey.

Back in 1960 xenophobia, in the form of racism, had been a deeply concerning issue for Malcolm Arnold. He was so moved by the violence meted out to the community of West Indian immigrants living in London's Notting Hill by bone-headed neo-fascist thugs that a symphony (his fourth), commissioned by the BBC, turned into a passionate appeal for the brotherhood of man to overcome all the violence, fear and mistrust. 'I was appalled that such a thing could happen in this country. The use of very obvious West Indian and African percussion instruments and rhythms was in the cause of spreading the idea of racial integration.' There is no clear storyline to the music. It is up to us, on the dramatic four-movement journey, to unravel and interpret the ambiguities our own way. But this richly rewarding symphony, after bringing us through harsh confrontation and poignant loss, clearly ends with the same kind of spirited statement of hope that we meet on the Walter Tull Memorial.

*Malcolm Arnold*
SYMPHONY No. 4
LONDON PHILHARMONIC ORCHESTRA
MALCOLM ARNOLD

Lyr

Malcolm Arnold conducting his 4th Symphony.

# 60. Yearly Festivity

The Northampton Town Festival, held at two large arenas on the Racecourse over a July weekend, is a great jamboree intent on bringing everyone happily together. Some 40–60,000 people attend. Another summer event, the university-inspired Northampton Music Festival, similarly aims to foster the celebratory spirit, showcasing town-based musical talent on as many as eighteen different stages. 'You never know what you will stumble upon,' explains project manager Yoshe Watson, 'It could be some classical music being performed in a café, or a rock band on an outdoor stage – whatever music you're into, you'll find something you like.'

Strong Northampton roots have also enabled the Malcolm Arnold Festival to flower each October. Artistic Director Paul Harris sums it up as, 'Some of the country's best artists performing some of the country's best music.' One of its unique features, he suggests, is the way the stars of today are supported by the stars of tomorrow, citing as an example the annual concerts of remarkable quality given by the town-based County Youth Orchestra. 'The combination of hard work and talent is amazing! They're almost certainly the finest orchestra of their kind in the whole country.'

Such yearly festivities embody the town's pithy Latin motto *Concordia fortior castello*: 'We may no longer have a castle, but we've something even better – great team spirit.'

Paul Harris at the Derngate with Arnold Festival celebrities Hayley Mills (2010) and Dame Monica Mason (2013).

# 61. Zeal for the Future

Pigeons swirl around the site of the former St Edmund's Hospital, for long a derelict eyesore but at last in the process of redevelopment. The town's current zeal for the future has been tempered by a sensitivity towards its unique industrial and cultural heritage. Yet demolition signs appearing on ancient buildings can still stir up old anxieties. The disused hospital clearly had to go. But what of the Gilbert Scott workhouse at its core? It was, as English Heritage declared, one of the first generation of new Poor Law workhouses: 'It represents a key moment in changing social attitudes towards the provision made for the poor and destitute'. Do the pigeons swoop around in justifiable concern? Or in grateful reassurance at another piece of sensitive officialdom? The answer will be informative.